Girlfriends

by Jayne Wexler and Lauren Cowen

RUNNING PRESS

PHILADELPHIA · LONDON

9 8 7 6 5 4 3 2 1
Digit on the right indicates the number of this printing

Library of Congress Cataloging-in-Publication Number 98-68465

ISBN 0-7624-0616-X

Typography: Bembo

This book may be ordered by mail from the publisher. Please include $2.50 for postage and handling.
But try your bookstore first!

Running Press Book Publishers
125 South Twenty-second Street
Philadelphia, Pennsylvania 19103-4399

Visit us on the web!
www.runningpress.com

In Memory of Gumaro Hernandez Chasco

—◆—

To my wonderful group of friends, incredible women all,
whose understanding and compassion touch me so deeply.
—JHW

To Jay for risking our friendship way back then
(even if you did have to listen to Rickie Lee Jones) and for this lifetime of adventure.
—LJC

contents

acknowledgments

A huge debt of gratitude goes to our agent, Susan Raihofer, who was there for us even when we didn't know we needed her. Many thanks also to Patty Trentini for her great ideas and production help (we're glad you're not an astronaut), and to Jamie Bischoff for looking out for us once again.

Our thanks to those who generously gave us everything from ideas to introductions and who opened their refrigerators, hearts, and homes, with special thanks to Wendy Alexander, Barbara Avnet, Jill Iscol, and to all the agents and publicists who helped so much, especially Handprint Entertainment and those at Susan Bymel.

For making us all look good, thanks to hair and makeup artists Tamami Mihara, Katsumi Kasai, Lana G., John Bayless, Pat Moore-Theis, Vered, and Katrina Borgstrom, with special thanks to Vartan at Vartali Salon. For locations we thank Bistrot Margot, Seize sur Vingt, the National Arts Club in New York, Barbara Hoppe of Fort Fisher, N.C., and thanks, too, to Craig Recording Studios.

This has been a truly collaborative project, and we owe thanks to many whose labor and insight brought this project together: especially editor Mary McGuire Ruggiero, who cared enough to get it right; Brian Perrin; pen pal J.B.T.; and a special thanks to our designer, Maria Taffera Lewis, who gave us her wonderful vision. Finally, we thank the rest of the Running Press team whose commitment makes a difference.

• • •

To my assistants for their great skills and sensibilities, with special thanks to Anissa Frey, Marion Soulie, and Dina Bradshaw, whose judgment and dedication helped so much; also thanks to Stephane and Robert from Arista for the fine prints, and thanks to Jeffrey Marks.

For my friends and family who saw me through from start to finish—Mom, Holly, Nana, Dad and Jan, the Goldsteins, and my new family, Elizabeth and Donald, Gretchen, Heather, and Shannon—you bring joy to my life; to my inspiration, Alida Fish; to Joan, Richard, David Waitz, Daniel Kron, Me-Me Annis, and Susan Ronick Debbie whose support, as always, matters, and to Hunter, my soulmate— the pies are much sweeter when I share them with you.

—JHW

Reporting and writing this book took me away from my family, and I owe a special debt of gratitude to my children, Avery and Eric, who at seven and four taught me a great deal about trust and love; and to the caring friends who watched over them when I couldn't: the staff at New Horizons Montessori, Susan and Brian Hitchings, the Trentinis, Deena Diorio, and Kim Sharp.

To my Mom, Dad, Stevi, and Randi, who first taught me what it meant to be a friend, and to those who picked up from there: Linda Greenberg, D. St. G., Lora Cuykendall, Tam Wahl, and Tanya Barrientos. To James Rahn: for a man of your gender, you're a hell of a friend. And to the rest of the Cowen clan—Mom, Dad, Frannie, Robin, and Marci—thanks for the support.

—LJC

introduction

NOT LONG AGO, I WAS ON A TRAIN when the subject of this book came up.

Beside me was a professorial-type, a man who was getting off at Princeton and who, for purposes here, I'll call "Mr. Mensa." He had weighty things on his mind. On his lap was a textbook with an unintelligible cover. He had the demeanor of someone who could speak several dead languages.

I was shuffling through my briefcase, then shuffling through pages, which must have annoyed him, for he looked my way with a pained sigh and then finally asked what I was working on.

"I'm writing a book."

"Hmmm. Fiction?"

"Well, no, Nonfiction."

"About?"

And here is where I'd like to say I launched into a powerful description of this book and why friendship means so much to me. I wish I'd explained that, although my family fills my heart, it's my friendships with women that keep pace with its rhythms.

But what I said was something like, "Oh, you know, it's about, well, women's friendship. Actually, it's a photo-essay book," the suggestion being that this project was a lark, as if it were what I do to pay the mortgage so I can write about the *real* and *profound* matters of life.

"Well," Mr. Mensa said, smiling generously. "I guess there's quite an appetite for that sort of thing." Then he headed out of the train car, and as the cold wind hit me, so did the discomfort of believing one thing and saying another, which I'm determined to rectify now.

The truth is my girlfriends are what keep me from coming undone. The women and girls in this book have reminded me of why that's worth celebrating in more ways than Jayne (my collaborator and friend) and I imagined when we set out to do this book. They drew us into their worlds and refocused our attention, stopped time for us, fixed our gaze as if to say, *Don't look away too quickly. Here, this here is what's worth taking time to think about.*

Which is what our own girlfriends have long since done for us. And we came to this project with them in mind.

We both rely on a varied circle of friends, Jayne's larger than mine. I've met most of her friends, though not all because that would require visiting every city, if not every continent. I count myself gratefully among them since a few years ago, we didn't even know each other. Now, Jayne knows me down to the details—what I'll always forget on a trip, for example.

And she has befriended most, if not all of my extended family. She knows the latest triumphs and trials of my closest friends and how each drums a different rhythm in my life.

Of all of them, she probably knows the most about my friend Donna St. George—with whom I talk sometimes six times a day. Donna and I met in the drafty basement offices of our college newspaper. From that time on it seemed impossible to imagine not having her in my life. We both write, have two children, and talk about everything and nothing because it tells us who we are and where we're going in life.

We have the usual currencies of friendship—our own language, history, jokes—as well as some things that mystify us; voices so similar our husbands confuse us. And then there is the universal truism of good friends—that we feel free to say or do anything, having that deep comfort that comes from knowing all we want is to see the other thrive.

"You should have married Donna," is how my husband sums up our alliance.

To which I reply, "If we were sexually compatible, I would have."

I share this private joke because it touches on our intent here. Jayne and I came to this project feeling strongly that relationships between women are unique. For all the sexism this might imply, we just don't see men relating the way women do. That perception shaped our search for stories: we excluded stories of relationships involving sex or immediate relatives or guys.

What we looked for were women who could bring the relationship's essence to the page, who could convey and articulate its defining gifts—the way friends talk and act, how their regard for each other shapes women's lives.

The stories we found and the people who tell them gave us days of immeasurable pleasure. These were friendships celebrated through wild excursions, history or hobby, the accidents of fate that our friends make memorable and which, were it not for them, would pass us by. For reminding us of this, we owe those who participated in this book our deepest thanks.

Early on in this project, I happened to talk about the book with a young woman named Brooke McLoughlin. Brooke was in her last year of college at the time and when she baby-sat for me that summer, we'd talk about many things. I valued her fresh perspective and caring mind.

Eventually she told me of a dear friend who was terribly ill, a woman who was close to her mom, and to Brooke. She talked of her often and told me that she would race home when word came that she had died.

On a day when I was particularly preoccupied with this book, Brooke was watching my kids and I went for a jog to clear my mind.

When I came back, Brooke was at the door, and the look on her face made my heart stop. "She's gone," she said. I searched her face and my mind for the right thing to say. "She must have been incredible," was all I could think of.

The next time I talked to Brooke was after the funeral. She talked of the amazing outpouring of love that was there, how this one woman had touched so many lives.

We turn to that story now (which is included here) because of what it reminds us of: beneath genuine friendship lies a reservoir of faith and strength and love that can see us through the worst and best times. If we started this project intending to bring moments that moved us to life, we end it longing to linger with the women we interviewed, to celebrate as they do, and to say to the Mr. Mensas of the world, "This is the important stuff of life."

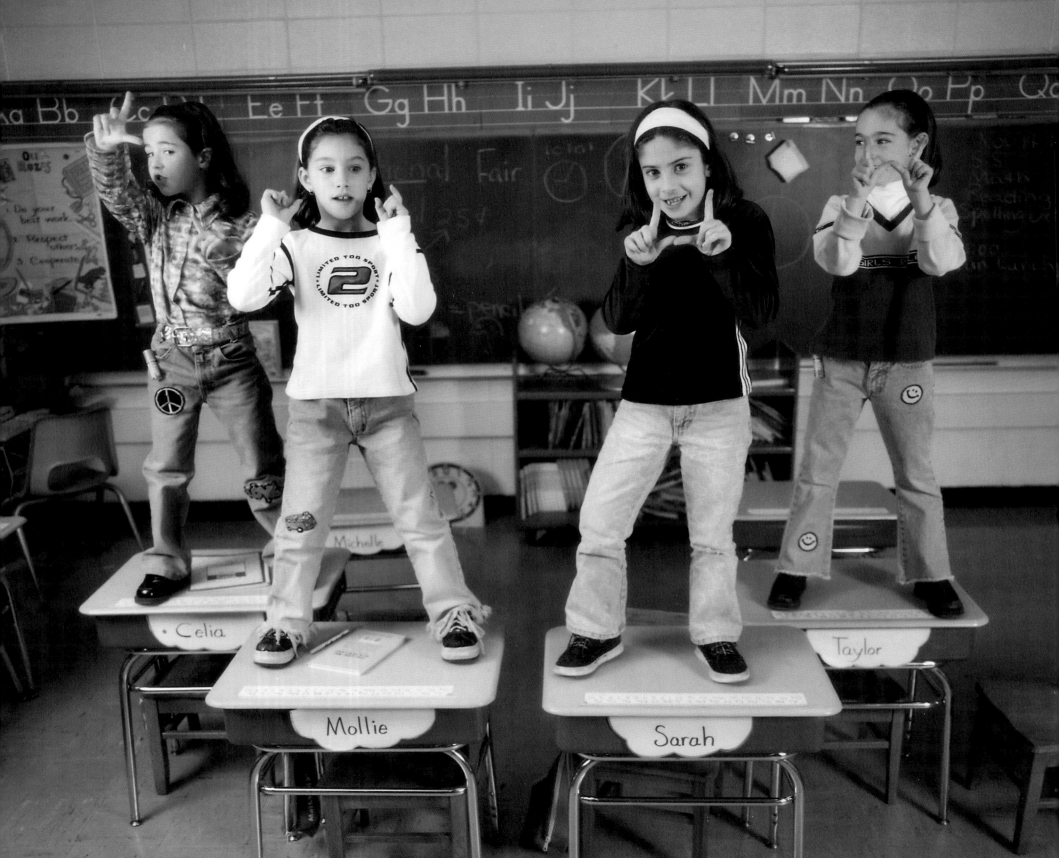

celia bernheim
sarah feinberg
taylor lustig
and mollie reinglass

Girlfriends and classmates
Celia Bernheim, Mollie Reinglass,
Sarah Feinberg, and Taylor Lustig
(left to right) strike a pose atop their desks.

though it seems impossible to them now, there was a time when this foursome didn't exist, when they wandered aimlessly in the parent-defined, singular world of life before age five.

Then came kindergarten.

"And now it's like we'll be friends for maybe 2,000 years," considers Taylor Lustig.

"Until infinity," says Mollie Reinglass.

"Until we're really old," says Celia Bernheim.

They can say this with certainty because they are in Miss Bruce's second-grade class and because they know a lot about each other, and because it seems to them standing here, together in a classroom after school, that the world will always be like this—warm inside, darkness coming outside, all of them together with no place else they'd rather be than with each other.

"Like my favorite color's purple," says Mollie. "I like darker colors and . . ."

"I like green," says Sarah Feinberg.

13

"I don't like hot pink," says Celia. "I like dark blue, light blue, green . . ."

Celia explains, "We try to like the same things because we all want to be friends but we don't always. Like if Taylor's favorite color is purple, and Sarah's favorite color is purple, and my favorite color is pink, well, sometimes, you think uh-oh, because you don't want to get embarrassed, because, like, you don't want to be the only one out of your best friends to like something."

"Well, I don't really have a favorite color," considers Taylor. "But some colors I like for certain reasons. I like red because of the Bulls."

"And the Blackhawks," adds Sarah. "We like black and white for the Blackhawks. Or like green and gold because we like the Green Bay Packers. We don't like the Bears because they always lose."

They probably don't know—or care—that psychologists look at this age as the time when girls develop fierce alliances with their girlfriends, which have profound effects on their lives. What matters to them now is being together. They believe in destiny—that they will be friends forever.

They believed once, though certainly not anymore, in the Spice Girls. They believe in the Chicago White Sox and the Chicago Bulls—but definitely not the Chicago Bears.

They believe power comes from knowing how to be cool.

Taylor explains, "See, the thing is, when we met, I had learned how to be cool from my older sister, Carli, and also I have a grandma who everyone says is cool because she wears bell bottoms. And then I taught Celia how to be cool . . ."

"I was already halfway cool," says Celia, "but Taylor, she taught me how to be all the way cool—she showed me all the clothes in her closet and we looked at my closet and figured out which clothes I needed. And then I taught Sarah."

And Mollie? A quick inventory of glances and then, "Well, Mollie was already cool."

Mollie confides that her Aunt Elanit, who is "kind of a hippie," helped her out in this area.

Lest you think their devotion is strictly a matter of appearance, they hasten to explain that they all know true friends are there for one another in a crisis, in bad times (when one gets sent to the nurse, they all go) as well as good. After all, a movie is only as much fun as the foursome you see it with.

"We care about each other," reflects Taylor. "We laugh a lot. We don't fight. We help each other."

Says Celia, "We learn from each other. Like if you get in a fight with someone then you don't play with them for one day. Then like you get back together with them, and you learn that that's a nice thing to do. Because if you don't, you might not have any friends at all."

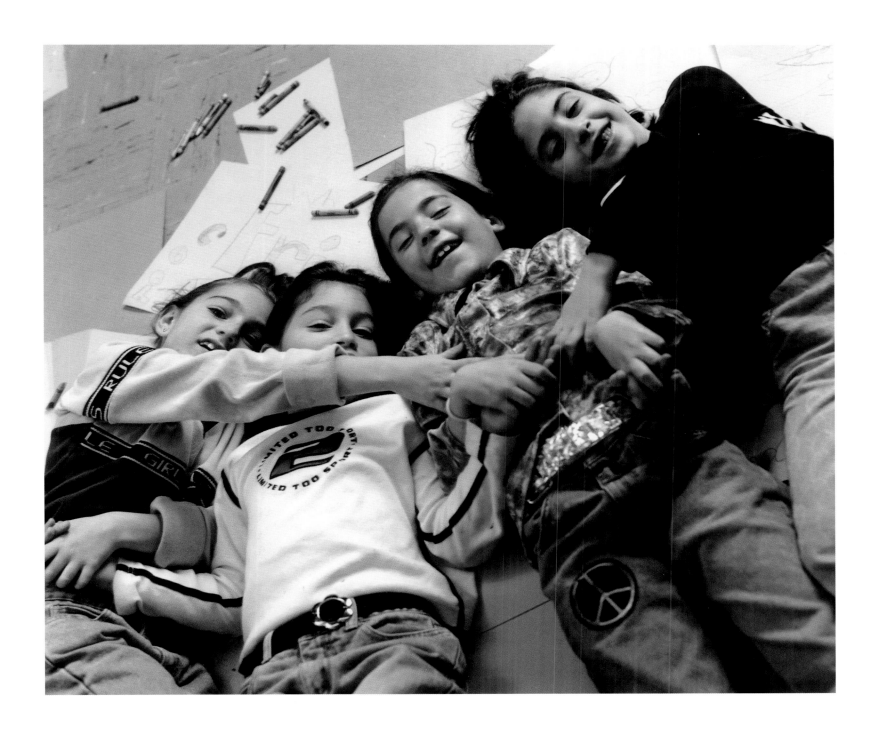

meghann birie *and* katie holmes

before she became Joey, the star of *Dawson's Creek*, and the sought–after ingenue who would appear in the acclaimed film *The Ice Storm* and on the cover of *Rolling Stone* and *Life* magazines, Katie Holmes was just a kid who loved her Barbie dolls.

Her cohort in this passion was her closest pal, Meghann Birie. They spent the weekends of their childhood traveling between their respective Barbie worlds—one in the basement of Katie's home, the other a bike ride away at Meghann's.

Today, they are hard-pressed to recall a critical moment when they have not consulted each other: over which shoes to buy, how to get through the first day of an all-girl Catholic high school (they made Katie's mom drive around the block several times so they wouldn't get there too early), or most notably what to do when it became clear that Katie was headed to stardom instead of college as they had planned.

But this was nothing compared to the test their friendship endured when they were eleven. Meghann stunned Katie by putting away her Barbie dolls for good.

16

Katie Holmes (left) and Meghann Birie in Fort Fisher, North Carolina, near the set of Dawson's Creek.

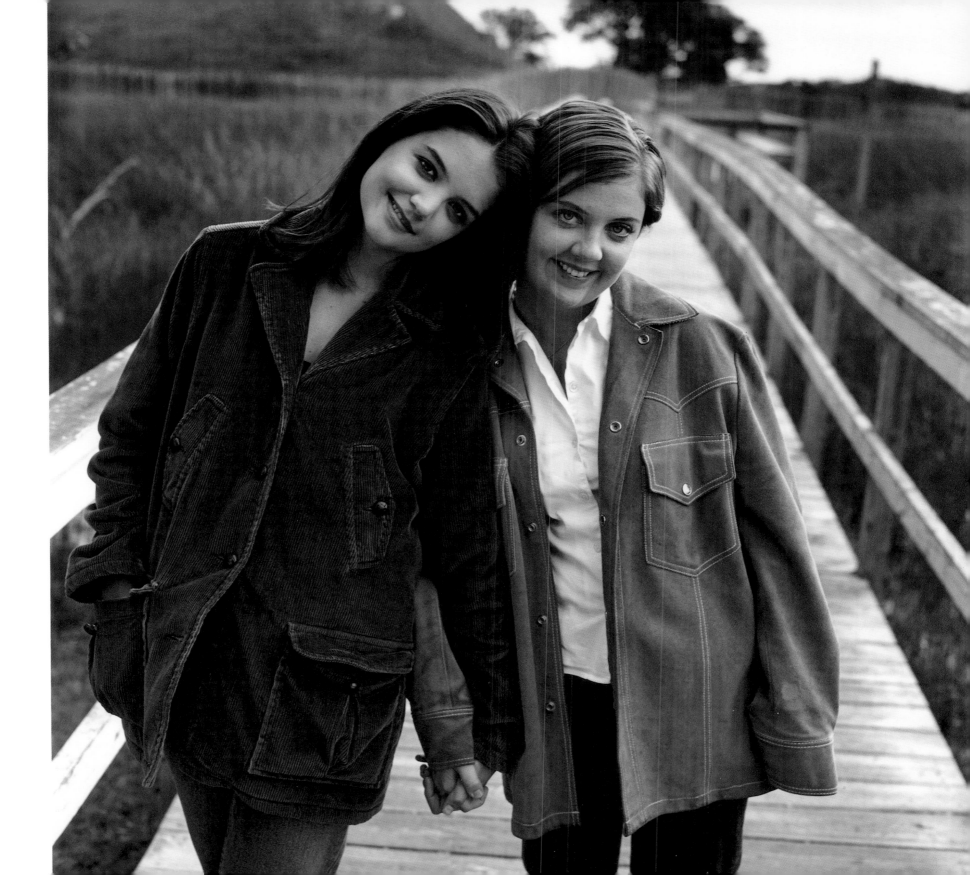

"How could you?" Katie remembers wailing. "How could you change?" The worst was yet to come. She was about to have a birthday party in her basement—her first boy-girl party, a momentous occasion. She and Meghann planned everything, especially games—passing oranges under the chin, passing Lifesavers via toothpicks—games they had imagined might lead to a first kiss.

Meghann surveyed the pre-party landscape and saw, to her horror, Barbie dolls everywhere.

"Katie, the time has come," she said firmly. "The Barbie dolls have to go."

Recalling this while eating lunch near the set of *Dawson's Creek,* Meghann pauses mid-fork and sighs. "It was hard," she says earnestly. "She didn't take it well."

"But we survived," Katie points out.

Which is perhaps why, when it came to issues of geographic separation, not to mention having your best friend suddenly swept from the lead role in the school play to the lead story in national magazines, Meghann Birie and Katie Holmes never questioned that their friendship would endure (though special thanks is owed to the inventor of the cell phone).

Consider Katie shopping for footwear. She pulls out her phone and dials Meghann, who might be on her way to class. "I'm in Nine West," she says, "and I'm looking at the boots, you know the ones . . . not the ones that go up to your calf, but the flat ones. . . ."

Or consider Meghann, sitting in class at Ohio State University. Surreptitiously, she dials Katie, who might be on the set of *Dawson's Creek.* "Oh my God," she whispers. "There's this really hot guy in front of me. Should I talk to him? I don't know, I'm a little intimidated. . . ."

Or imagine, as the two of them do, what will happen when some guy proposes marriage.

Says Katie, mock-phone to ear, imaginary boyfriend across the table, "Hold that thought!" She pretends to dial Meghann. "So. Should I marry him?"

They giggle at this, suddenly just two girls from Toledo who share a past and a refreshing outlook that leaves little room for irony or cynicism.

"We've always been like sisters," Katie says, turning to Meghann. "Ever since kindergarten, when I saw you in those overalls."

"And then in high school, oh my God, remember? We were such nerdy freshmen."

"Totally nerdy," Katie agrees.

"Remember that first day?" Meghann says. "I rolled up my skirt, thinking it looked better. . . ."

"And remember we wore lots of ribbons? So dorky!"

"Plaid ribbons!" recalls Meghann in horror.

They didn't make the cheerleading squad because they talked too much. Meghann coaxed Katie into taking dance lessons with her. They had favorite television programs, *Saved by the Bell* and *Full House,* and secret outings to watch movies their parents deemed inappropriate, such

as *Weekend at Bernie's* and *Girls Just Want to Have Fun.*

For fun, they invented and taped make-believe newscasts. Meghann was always the weather girl. Katie, for some reason, was the news anchorwoman "Janet Jackson."

"She was really dramatic in singing and making up commercials, stuff like that," recalls Meghann.

In a bid to teach Katie etiquette, her mother enrolled her in a Toledo modeling school. There, she took acting classes and went on the school's trip to New York for the International Modeling and Talent Association convention. It was at that convention that Katie, then sixteen, performed a monologue from *To Kill a Mockingbird,* a performance that sent thirty agents scrambling to find her home phone number

But she was only a junior in high school, and had already been accepted to Columbia, where she planned to major in pre-med. Heading to Los Angeles for screen tests was not what her father had had in mind.

Eventually, Katie's pleas held sway. Her first audition was for the movie *The Ice Storm.* James Schamus, the film's co-producer and screenwriter, told *Rolling Stone* magazine that they were simply looking for someone to read a few lines against an actor and snatched Katie from the hallway. "She read for a few minutes, and after she left, I turned to the director and said, 'This is it. This is a movie star.'" She got the part, but was away from home for six weeks.

"I kept calling her all the time," Katie says of Meghann.

"It was really hard. We had never been apart for that long."

Soon after, Katie auditioned for *Dawson's Creek* via a videotape she recorded in her mom's sewing room, with her mom reading Dawson's lines. Once the show's producers saw the tape, they asked to see her immediately. Since she was busy performing in her high school play, *Damn Yankees,* and didn't want to let her friends down, the producers agreed to reschedule her audition. Katie won the part of Joey, one of the lead roles in the show.

So while Meghann began her freshman year at Ohio State, Katie moved to Wilmington, North Carolina, where the show is filmed. Via cell phone, Meghann hears behind-the-scenes stories and has visited Katie on the set. When the show airs each Wednesday night, she watches with her new college friends.

"I get so many questions!" says Meghann with a laugh. "She'll call, and my roommates will put their hands over the phone and say, 'It's Katie Holmes!' Then they'll worry that they sound too starstruck. But when they hear me talk about her, they say, 'Well, she must be so easy to talk to. She must be just like you.'"

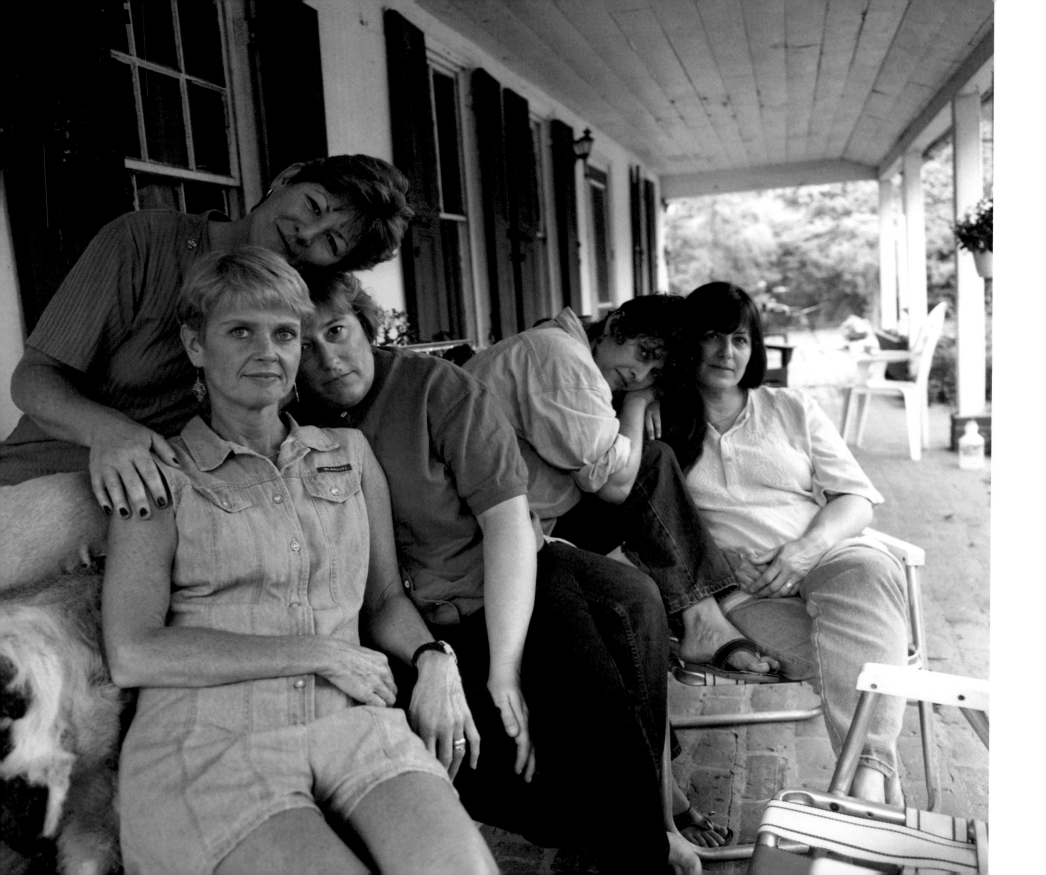

rosemarie brown
bernadette butcher
kathy evans
kathy james *and*
annmarie mcloughlin

Rosemarie Brown, Annmarie McLoughlin,
Kathy Evans, Kathy James, and
Bernadette Butcher (top left to right)
gather in Oreland, Pennsylvania.

t his they know for sure: Loretta is gone, but they have each other. Neither seems possible.

"I don't know how, and I still don't know why," says Bernadette Butcher. "All I know is that it happened. We're totally different people, with totally different interests, and it's so strange to think we came together."

How to explain to someone who wasn't there? They were women who lived ordinary lives. They tended homes and children and marriages. They knew love and loss and age and Loretta Ehling. But they never really *understood* each other as friends until they learned that Loretta was going to die.

In Oreland, Pennsylvania, the small town where they live, Loretta's legend was already large. She was the mother of four school-age children, and seemed to be the woman on every committee, at the heart of every fund-raiser, the one who got everyone to do what would not otherwise get done. But perhaps her greatest gift was less often heralded: She had an instinctive talent for seeing inside her friends' souls and strengthening the frailties of their hearts.

"I felt like I could tell her my deepest secrets and she understood what my problems were, like she had them too," says Kathy Evans.

"She always had the Band-Aid, the ointment, the right words," says Ann McLoughlin, who most often talked to Loretta about faith and spiritual matters. "We had these deep, deep discussions. She made me—and I think all her friends—feel like I was the priority."

Bernadette remembers finding Loretta on her doorstep, aware that Bernadette had a preference for solitude.

"I wouldn't talk to her for weeks, and then all of a sudden she would just show up. It was so strange, like she was reading my mind," says Bernadette. "She'd say, 'Come on, you've got to come to this or that' and I'd protest, like, 'No, no, I'm not going.' But she knew I needed to get out of the house.

"And you have to understand she did this for everybody," she continues. "She'd hear someone say, 'Oh, my kid has a confirmation and I can't find shoes,' and the next thing you know she's found you somebody with the same size who just happens to have them. Whenever you went somewhere with her, you didn't have to worry about bringing anything, because she always had it. You name it."

Rose Brown says, "I'd call her late at night, looking at my kids' stuff and realizing that they need something for school the next day that I wasn't sure I had. She'd know exactly what they needed."

"But she wasn't perfect," points out Kathy James.

That makes them all laugh. "Oh, God no! She wasn't perfect,"

says another. "She was always late. She saved everything. Her house was usually a mess. She had trouble letting things be."

This just made her all the more human. Her friends say she had the faith of a child, believing in everyone and everything, and this made her seem solid, as if made of hardier stuff.

Then one day, just like that, Loretta was diagnosed with cancer. And it was in her dying that she offered up a lasting lesson for all of them, a lesson about life.

the phone rings and everything changes. Kathy Evans remembers standing in her bathroom clutching the receiver, her eyes locked on tile and grout. "It was such a shock. An unbelievable shock," Kathy remembers. "It seemed that Loretta was always going to be there, because she was always there."

Loretta had gone to the hospital for what everyone believed was a routine stomach ailment. The doctors were stunned when they found cancer instead.

From that moment, Loretta vowed her own private battle of wills, posting a sign in her hospital window: *No Negativity Allowed.* Her friends made their own pact. They would do whatever it took to keep her alive. Each offered up a different personal strength: Loretta would rely on Kathy Evans for comic relief; on Bernadette for her calmness and quietude; on Kathy James for her wild spontaneity. The work they'd always done— caring for families and friends—that usually goes unnoticed, suddenly became essential, and it was if they'd been training for this job all their lives.

Their first order of business, they knew, was to raise money. None of them had much, and Loretta earned little as a medical receptionist. So Bernadette, Rose, the two Kathys, and Ann, turned to another of Loretta's friends, Sissy Ragg, whom they knew to be an expert in fund raising. She took on the project—what would be a beef and beer—with the zeal of a missionary. Everyone wanted to give something to what they would call the Friends Care Fund.

Loretta was horrified at the prospect of a party in her honor. "You have me dead already!" she told them. As someone who had always done the giving, she didn't know how to take. They waved her off, telling her, "You're going to love this. This is so you!"

Phone lines buzzed. Neighbors who barely knew Loretta left envelopes with money on the friends' doorsteps. Florists promised arrangements, a gas station offered up a door prize, and school children made decorations. The beef sandwiches were donated. So were the beer and the church hall.

The evening of the party, huge swags of balloons filled a room where there was deep warm light. The place pulsated with the pump-pump of amplified music, with dancers swaying, limbo-ing, and circling in a long conga line. The church basement was alive with heat and music: Motown and Elvis, and rousing country tunes for two-stepping. Waves of good will drew all of them upward until they were singing and toasting with plastic cups and waving arms and high-fives, alive with the certainty that nothing bad could happen here.

But as people began to leave, someone began to cry.

The friends drew Loretta to the center of the floor, wiping tears and dabbing blotches of mascara from each other's faces, laughing at themselves—at their collective sight. They locked arms and swayed, a tight knotting of friendship, their voices mingling in midair, singing along with Dionne Warwick to "That's What Friends Are For."

"It was this really great moment," recalls Rose.

"I remember having the feeling that here was Loretta making this big tapestry," says Ann. "You could literally feel her pulling everyone together. We were all part of this big picture, and it made us feel so lucky just to be part of it. I thought, *This is what it means to be alive.*"

they fell into routines and roles that seemed right, bringing food to Loretta and her family, making sure her kids got where they needed to be. They tried to ensure she was getting the best medicine, and helped her look at treatment options. They prayed—Catholic prayers, Jewish prayers, anything they could think of—and performed Native American rituals that Kathy James suggested.

"I remember sitting in this sweat lodge and looking around at these Catholic suburban women, who you'd never in a million years believe would do this. Only Loretta could make all that was different between us seem like something that was just interesting," she recalls.

One weekend, they ushered Loretta out of the house for an anniversary outing with her husband, John. Then they set to

23

work redecorating the bedroom, which Loretta had always meant to do. They cleaned out drawers, papered the walls, and decorated every surface with little gifts from friends.

"We did it all in pink and white flowers."

"And angels. She loved angels."

"Remember she said how John didn't like her nailing stuff to the walls?"

"Yeah, so we hung everything."

Her friends knew Loretta needed to rest. They wanted her to be surrounded by warm images and to find in her room all the comfort she had brought to them. More than anything they wanted her to learn how to rest.

"You can't imagine how hard that was. I mean, here's a woman who, the Christmas Eve of the year she's dying, is out feeding the homeless, then shopping for gifts, then coming home to throw a party," Ann recalls.

By May, they all knew that Loretta's body was giving out. For weeks they shuttled between their own homes and jobs and the bedroom sanctuary they'd made for her, which had become the place where Loretta, at age forty-seven, would die.

"I miss her terribly, you know?" says Ann, the rims of her eyes reddening. "I didn't expect it to hurt so much. Sometimes I still pick up the phone and start dialing her number."

"So do I," says Kathy Evans.

"It's like holding onto a balloon," Ann says. "You just let go and it's—it's gone! My father and my brother died, and that was horrible, but in a way, I could handle that. I just wasn't prepared for this. It's like a good friend

completes you in an entirely different way."

"But I think we're lucky, don't you?" asks Kathy.

"Her story is a beautiful story, don't you think?" says the other Kathy. "I don't think I'll ever live through something like that again, where someone's dying brings all these special people together."

It's been nearly three years since the beef and beer party. They've established a foundation in Loretta's name, with the intent of raising money and creating a haven for others who might need help. They still check in on John and Loretta's four children, making sure John knows they are there if he needs help.

They think of what Loretta would say now, watching them—as they're sure she is. They sit on Bernadette's porch, sharing a few cigarettes, taking puffs, passing them down the line with guilty expressions, as if Loretta herself were about to round the corner and reprimand, "Don't you know that stuff will kill you?"

"She'd be so glad that all of us are friends, that we mean so much to each other now."

"Yeah, but I also think she'd be kind of pissed at us, like, 'You guys are sitting around saying all this about me? I'm not a big deal!'" They laugh at this.

The big deal, they know, is what they learned from Loretta's life and what they found in her death: faith in what remains a great and relieving mystery—that the blessing of friendship survives the loss of even the greatest of lives.

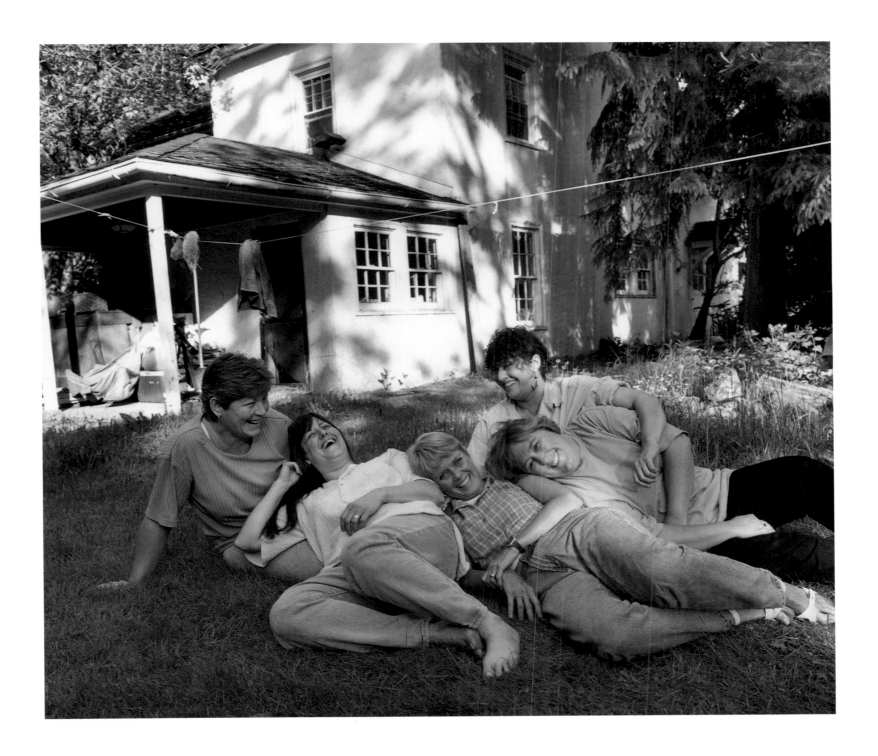

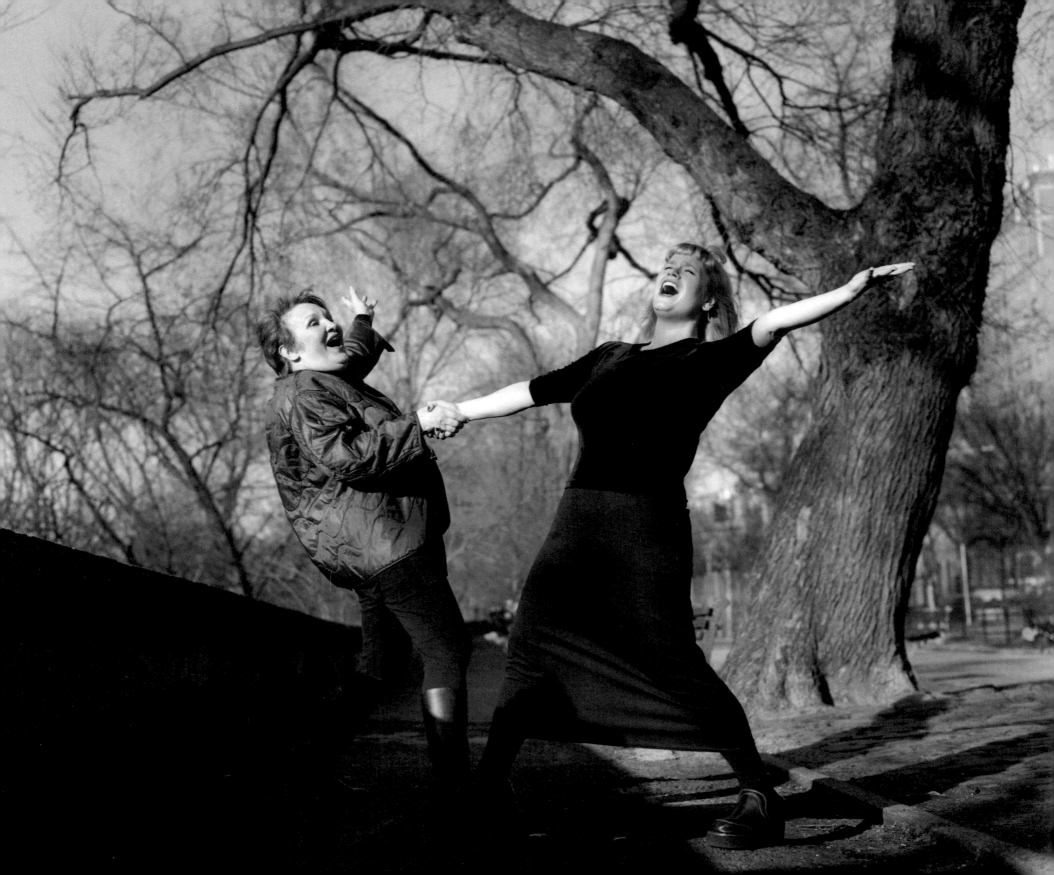

stephanie st. john
and luba tcheresky

*Luba Tcheresky (left)
and Stephanie St. John
rejoice in their friendship
in New York City's Riverside Park.*

On a hot August day, in the middle of her twenty-second year, Stephanie St. John stepped off the subway, walked two blocks uphill, and then rode the elevator to the place where Luba Tcheresky lived.

What had brought her to the city was the same passion that brings scores of other twenty-somethings to Manhattan—a search for fame. What brought her to this particular doorway on the Upper West Side of New York was the advice of a friend, who had told her Luba was the person she needed to see.

Luba was known as a great teacher. She had long since sung on the great opera stages of Europe and the United States. She had won critical acclaim, had been likened to Maria Callas.

As Stephanie approached the doorway to Luba's apartment, she steadied herself against her own discomfort. She'd never gotten on well with teachers, voice teachers in particular. And if she had the conviction of her talent, she also had the hesitancy of one who knows what it is to have been silenced. Stephanie's mother had suffered psychiatric breakdowns that didn't leave much room for her young daughter to discover who she was. And her father had stepped back into her life when she was a teenager, suddenly wanting to redefine who she'd decided she could be.

The alliance of these two women—one an aspiring singer in her twenties, the other a worldly Russian-American—seems an unlikely one at best.

But as Stephanie entered Luba's home that day, she knew she was crossing an important threshold. Five years later, they'd be true comrades, having found a deep friendship that would ultimately allow Stephanie to find the power of her voice.

"What is so amazing," says Stephanie, "is that I didn't have to change to learn from this woman. I didn't quiet myself. I just was myself. And she completely took me as I was and made me blossom."

"That's right," says Luba. "This didn't happen with any of my other students, and I don't know why it is with Stephanie and me. . . . Friends my own age give me advice and talk about their problems, but they draw from their well of experience and tell you what they think is right for them. Whereas, when I'm talking to Stephanie, I am absolutely transported, as if I am in her situation, and I feel the same thing from her, as if she is in mine. And yet how can that be?"

They are in Luba's apartment, where that first meeting took place. It is small and crowded, but the walls show the great expanse of Luba's life—evidence of her travels and her performances of the great composers, and photographs of former students, some now well known in musical theater and opera.

On one shelf is a small black-and-white shot of a preteen Luba, strutting in bloomers and braids, on her face a widening look of youthful confidence. The image only hints at the adventures of her past: At age nine, she was sent, alone, on a boat from her homeland near the Russian-Polish border, where she'd been raised by her grandmother, the only caretaker she'd ever known. Ahead was the Statue of Liberty, and a mother, stepfather, and two stepsisters she'd never met.

Her mother, recognizing her talent, told her that she needed to sing to put "glory in her life." Soon Luba was performing in opera houses the world over.

As Luba tells this story, Stephanie shakes her head. "For me there is this great respect for what she's been through. Maybe it's not in spite of being from different generations, but because of it, that we're so tuned in to each other."

What Luba saw in Stephanie, from the very first, was a terrific talent, but also a hesitancy that came from Stephanie's uncertainty about herself.

"Your voice," Luba would tell her, "is your life's breath—whatever you say, wherever you say it, in a restaurant or talking on the phone. Whatever supports you in life, you use that same support in your singing. The voice is so internal. I would talk to Stephanie about what was happening in her life, with her family, her boyfriend. I wanted her to know that whatever happens in your personal life can affect your voice."

"I was so unsure of myself . . . " Stephanie recalls.

"Even with all that talent."

"Now I see that my voice has always forced me to be better. It's more powerful than I am, and it made me strive to be stronger and better."

What Luba shared with Stephanie was more than advice. She talked to her as she'd talked to few people, wanting her to understand how her teaching and life experiences had shaken

her own confidence. As Luba asked about Stephanie's boyfriend and family, she also began to tell of the most difficult time in her own life—finding herself suddenly without a husband, so bitter from betrayal that she no longer had the courage to sing.

That's when she turned to teaching.

"It was a horrible, dark period in your life," says Stephanie. "What really got you out of that period was getting back into your craft. I learned so much from that. I learned that you have to make room for what you love inside yourself."

"It was important for me," says Luba, "that Stephanie understand that. When I know somebody has real talent, they cannot allow anything in their personal life to kill that talent. A singer's instrument is their breath—the very breath of life. Everything that happens affects it. An unhappy bird cannot sing."

Stephanie knew Luba saw in her what she still describes as "the makings of a great Broadway singer, a star of the musical theater." But in time, Stephanie found herself heading in a different direction, writing her own music and lyrics. Increasingly, she longed to venture into a world that was farther from Luba's—that of singer/songwriters, and rock musicians who have their roots in smoky, out-of-the-way clubs.

On the day she finally confessed this to Luba, she was nearly as nervous as she was at their first meeting.

"I was afraid," she says. "I was afraid you wouldn't want me to do that."

"Well, my heavens!" Luba exclaims. "I don't want to change you. If that's what you want to do, my goodness, that's what we should be doing here. I want to hear you with your guitar!"

When Patty Burkhart and Christine Smith were teenagers, just home from school, they'd run to the phone. Their mothers shook their heads: "You saw each other all day at school! What more could you have to say?"

But there was always more. Theirs is a history of shared circumstances and sounds: the hiss of the school radiator, the car radio playing the Beatles and Herman's Hermits, the sound of the ocean as they walked around their favorite summer hangout. They talked because it told them who they were. They listened and thought of who they might become.

Then one day when they were twenty-four, Patty Burkhart couldn't hear. First she lost the use of one ear. A year later, she lost the other. Doctors said it was irreversible.

Even in those early days, Christine remembers Patty waving off pity, scribbling messages on her plastic pad—changing the method of their talk, but not their hunger for it.

"There were like two minutes when she cried and realized she'd never hear her husband's voice again, or her babies' cries. That was it. She never thought of the relationship changing, and I think that forced us to say, okay, we just have to develop other ways of talking."

Both learned to sign. Patty learned to read lips. They bought phone devices that printed the spoken word, and celebrated the advent of the home fax machine, which function as their cellphones, enabling them to communicate spontaneously about everything—paint color or politics or even the bird Patty just saw through her window.

"There is something you get in talking with a good friend that you can't get anywhere else," Christine considers. "As a kid, you're trying to piece together who you are. I'm close with my sisters, but they're five and nine years older. You don't find the same understanding as you do with a friend."

patricia burkhart
and christine smith

Lifelong friends Patricia Burkhart (left)
and Christine Smith

leona rostenberg
and madeleine b. stern

One day, in the Long Island cottage where they spend their summers, two women sat before a typewriter, a nearly finished manuscript in hand. One typed. The other shaped thoughts aloud. They worked to a rhythm only they could hear, one that comes only from knowing the inner workings of a dear friend's mind.

There are other writers like them—two minds who collaborate on the page. But there is only one Leona Rostenberg and Madeleine Stern. They met as aspiring academics in the 1930s. They have shared homes and confidences and business partnerships as rare book dealers—a collaboration that spans sixty years of scholarship and adventure. Together they have done what few women of their time dared do—they chose a life of the mind over a life centered around marriage. But it is their discoveries that distinguish them. They are sleuths of a rare order—a pair the *New York Times* dubbed the Holmes and Watson of the rare book world.

On this particular day, they weren't writing of the hidden lives of famous authors. They were writing of themselves—their own autobiography.

"Our lives are our legacy, and it is a legacy dominated by the first

person plural," they wrote. "The delights we have discovered in detection were possible only because we detected and discovered together. We have been companions in the search; we have rejoiced in unison. We share our achievements and our hopes. We still end each others' sentences. Together we look to the future—to our next find, to our next book, to our next adventure."

Thus ended *Old Books, Rare Friends,* but not the passion that drives Leona Rostenberg and Madeleine Stern.

"To us, it's so incredible," Madeleine says. "When we were asked to write this, we couldn't understand why anyone would want a joint autobiography. We couldn't believe our ears. We couldn't believe that we are different from anyone else. We're not married, and we don't have children, but other than that. . . . What's unusual, of course, is that we get along."

"There is that," Leona agrees. "There are differences. Madeleine is a very rigid person, with set ideas. For me, if I don't get there tomorrow, I'll get there the day after tomorrow. But we discuss, we give in, we realize the importance of this."

Their most famous literary discovery remains their favorite.

"That moment will never be forgotten," says Madeleine.

At work on Madeleine's biography of Louisa May Alcott, they were sorting through documents in Harvard's Houghton Library. What they discovered shook the literary world.

They were investigating an assumption that Alcott had written under another name, which had never been proven—until Leona uncovered key evidence that day.

"It was just a matter of luck, really," she says.

They came to the library armed with the suspicion that comes from careful inquiry. They knew, for example, that her book *Little Women* was autobiographical and they suspected that she was far more feminist-minded than many believed.

"I was sitting here," says Leona. "You were sitting there."

"I took a bunch of boxes that were in front of me and she was working on her boxes," Leona says.

"I think they were in sequence," remembers Madeleine.

"They were not in sequence," corrects Leona.

Leona found a revealing piece of letterhead among other documents—a clue as essential to Alcott's identity as any fingerprint or bloodstain is to a crime.

And what did they do at that moment?

"We let out a whoop!" says Madeleine. "Which didn't sit very well with the curator of the Houghton Library."

"Naturally," Leona says and they both laugh.

That was years ago, but the moment is still fresh, as are the memories in *Old Books, Rare Friends,* which became a national bestseller. Now Madeleine and Leona sit surrounded by books and bulging file cabinets, with Bettina, their beloved dog, who climbs on the couch between them, circles once, then collapses with a tiny sigh. These friends have been together for so long, it's impossible for them to imagine what their lives would have been like if they had never met.

"Leona says she probably would have ended up in some Midwestern university," Madeleine remarks.

"Right," Leona says with a wry smile. "I'd be an adjunct professor in some middling university in South Dakota, having

married a pale-faced man and having had pale-faced children, missing all the excitement, all the adventure and travel and seeing the world."

"You see," says Madeleine, "good friendships are made of so much more than something esoteric like books."

They first met in September 1929, because they were two women with similar backgrounds who were raised with fine books, a love of education, and dreams of becoming more than a teacher or a wife.

They were both to teach at a Manhattan Sabbath school. But where Madeleine came to the job as a freshman at Barnard with a formal Jewish education, Leona, from New York University, was, in Madeleine's view, barely qualified.

She remembers saying to a friend, "Leona is lots of fun. But she is no intellectual," a comment Leona overheard and reminds Madeleine of to this day.

They met again, years later, as graduate students at Columbia University. Leona was working toward her Ph.D. in Medieval history. Madeleine was studying for a master's degree in English literature. Most of their friends were marrying, moving away, leaving academia, and Leona and Madeleine found themselves confiding in each other about their lives and hopes.

Leona labored on her thesis, a penetrating study of early printer-publishers. Madeleine wanted to write.

But Leona's thesis was rejected (Columbia finally granted her a Ph.D. thirty years later). The event, initially tragic, set the two on an exciting course. They inspired one another to learn and travel and study and write, and together they established what would become a New York institution: Leona Rostenberg and Madeleine Stern Rare Books. Leona became one of the few women presidents of the Antiquarian Booksellers Association of America. They published seminal works, and Madeleine received the prestigious Guggenheim grant for her work on Louisa May Alcott.

Could they both have accomplished so much on their own, without each other's support?

Madeleine doesn't hesitate. "It would be impossible. I know a lot of things," she says turning to Leona, "but still your knowledge of early printed books is more profound than mine, there's no doubt about it. You also have an astounding memory. You remember everything I don't . . ."

"Madeleine could certainly have created her literary success without me," Leona insists.

Madeleine waves her off. "I always read to you what I wrote."

"Yes, but it was you who achieved it. I didn't write it."

Madeleine insists, "I took your criticism. If it weren't for you . . ."

And so it goes. Certain words don't need to be said—or are summed up in the dedication of Madeleine's famed Alcott biography: "To Leona Rostenberg. A faithful friend is a strong defense. And he that hath found him hath found a treasure."

Juliann Swartz and Anne Christensen became the closest of friends while attending the University of Arizona.

They were young and beautiful, and saw in each other a reflection of themselves that pleased them, that told them who they might be.

"I have this image of us," Anne recalls, "literally skipping arm-in-arm, down the street, really young and adventurous. It's the way you are at that age of wanting to be seen, and yet being unapproachable."

But then, real life began. "Juli" moved to New York first, determined to be an artist whose work would lift up the downtrodden. Anne came next and rose to great heights as a stylist and a fashion editor at *Vogue* magazine. Now when they looked at each other, they began to see what they couldn't be.

"The jealousy and competitiveness were almost palpable," Juli says. "So much of that jealousy was letting go of my own expectations. I moved to New York with the idea of *Here is the opening of possibilities of my life.* . . . And then I started to make choices, and what I didn't choose began to fall away."

It was as if they were weighed by different laws of gravity—Juli worked in the city's underbelly, Anne aloft, surrounded by glamour.

Of course to Anne, her life was anything but glamorous. "I worked a very regimented day with people I didn't have much in common with . . . and there was Juli teaching, more carefree."

Over time, they saw that they were fighting their own insecurities, finding themselves so they could celebrate what they see in each other now. Says Juli, "It's as if our friendship came of age as we did."

anne christensen
and juliann swartz

*Anne Christensen (left)
and Juliann Swartz*

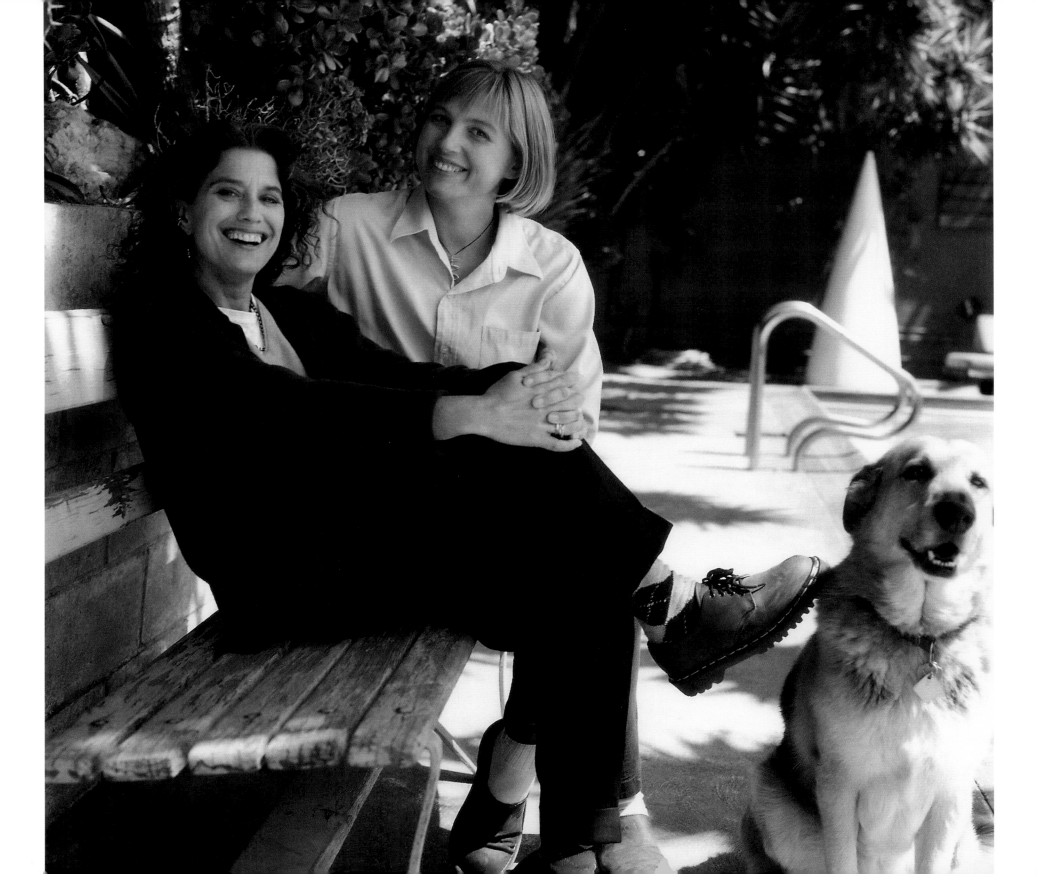

susan feniger
and mary sue milliken

*Too Hot Tamales, Susan Feniger (left)
and Mary Sue Milliken—
along with her dog Lewis—
sitting by the pool at Mary Sue's house.*

On one of their last nights in Paris, in a tiny apartment, Mary Sue Milliken and Susan Feniger set out to cook a meal they'd never forget.

By then they had paid their culinary dues the hard way—working for almost no money, under sometimes brutally insulting chefs. Now they were heading back to the United States and they had celebration in mind. They drank one bottle of wine while they cooked. They cracked open a tiny window in Mary Sue's apartment and pretended there was a balcony outside. And by the time they were through the second bottle of wine, they knew that not only were they ready to become great chefs, but they were destined to open a great restaurant.

39

They even wrote down names for their new place. Never mind that they had no idea how they'd pay for this venture. They simply knew, with the certainty that accompanies a fifth glass of French white, a list of names in a spiral notebook, and the dark promise of the Paris sky, that they would return to the States and share something extraordinary.

"There was this rainbow," recalls Mary Sue, "and I remember we sort of toasted the restaurant and figured all we needed to do was decide what city it would be in!"

"Oh my God, we were so flaky," says Susan, laughing. "I mean, we had no money and we thought, Well, gee, I've heard Phoenix is a nice place. Let's do it there."

If they only knew! On that giddy night in Paris, they were creating not just a place to dine but a powerful alliance that would bring both success beyond their wildest dreams. Publicly, they would become known to the world as the Too Hot Tamales, stars of television's Food Network and of their own weekly radio show, authors of five cookbooks, and owners of four famed restaurants.

They've been partners since 1981. They've been honored with many awards, and have been invited to cook with the legendary Julia Child on her own television show. Privately, events that might have pulled other friendships apart would only deepen their mutual fondness and trust.

They first met in Chicago at the famed French restaurant La Perroquet. Both were in their twenties (Mary Sue was twenty,

Susan was twenty-five), graduates of prestigious chef schools, determined to succeed. To get the job, Mary Sue wrote countless letters. She finally got an offer—as a hat check girl, but lobbied hard until she won a spot in the kitchen. Susan arrived months later. But for reasons that baffle them both, the chef decided Susan couldn't do anything right. Eventually, they'd win him over and become the first two women to run the grand kitchen. But Susan's early months were torture. "Oh my God, oh my God," she exclaims. "Every day at four there was a break and I'd go into the bathroom, I don't know how many times in tears, crying on Mary Sue's shoulder because he was such an asshole to me." Since all the other kitchen staff were men, they found refuge in the restaurant's fancy powder room.

"I would say to her, forget about it."

"Right. That's what you'd say. 'He's an asshole.'"

"And I would say it's still good experience, and then we'd talk ourselves into the fact that it was the best food we'd ever tasted, the best restaurant to be working at, and that we could endure what had to be endured."

"Yeah," Susan adds, nearly bouncing off her seat. "For no money!"

They relied on each other for just about everything, even transportation, riding to work on one bicycle: Mary Sue pedalling; Susan sitting on the handlebars.

Then one day, Susan took Mary Sue aside and with some nervousness told her two facts: First, that she was leaving— heading to Los Angeles where eventually she'd work with

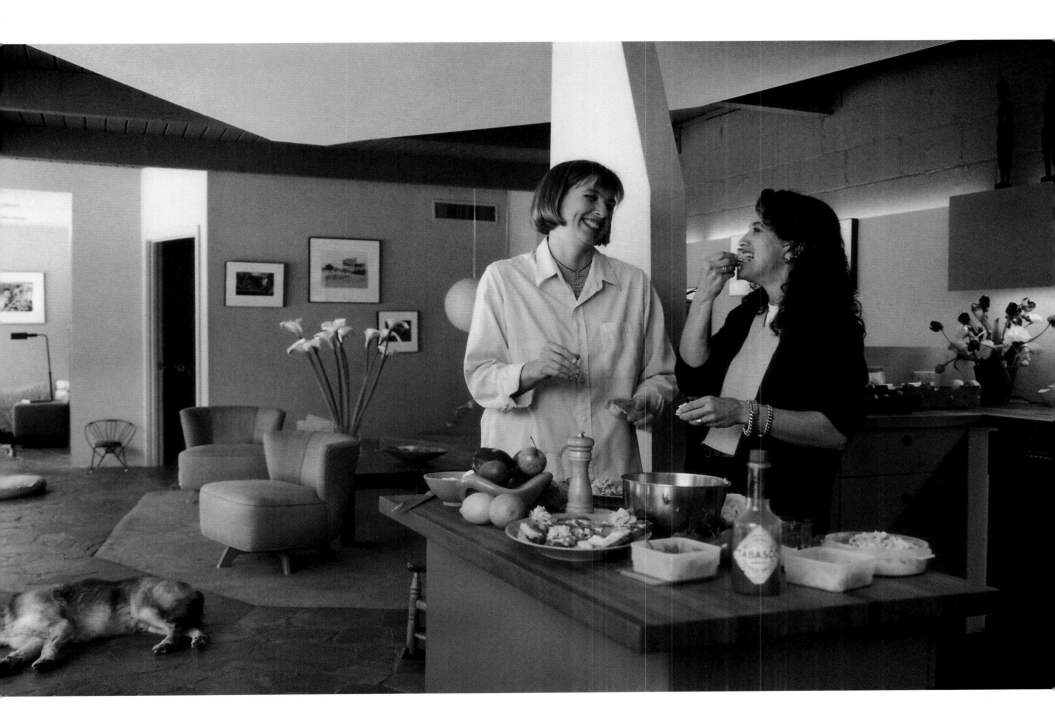

Wolfgang Puck. Second, that she was gay. Mary Sue was stunned—not that Susan was gay, but because they'd confided so much, and Susan hadn't mentioned this.

both later headed for jobs in France—Mary Sue in Paris, Susan in the Riviera—and kept in touch while they honed their culinary skills. This time, it was Mary Sue who was fighting tears and humiliation. Susan had a wonderful job where her coworkers treated her like family.

"Susan was calling me from the South of France, and the tables had completely turned. She was having a great time. . . . And I," she pauses dramatically, "I was in dingy, dark Paris where everyone was so mean to me! And here was Susan saying, 'You can hold out.' It was exactly like in the powder room at La Perroquet!"

When her job ended, Susan met up with Mary Sue in Paris. So it was on one of their last nights that they conspired to go into business for themselves.

"The place in Paris was so tiny . . ." Susan remembers.

"We pulled the mattress apart and I slept on the box springs," Mary Sue laughs.

"And there was no room to walk," Susan remembers. "But we had this really good time and we dreamed about this restaurant we would have. . . ."

Ultimately, they agreed on Los Angeles for the site of their first restaurant, City Cafe. But the real defining moment in that venture came a few years later when Susan insisted that her ex-husband, Josh Schweitzer, design the expansion to enlarge the place.

Josh had just become an architect, and Susan wasn't content to leave behind unsettled feelings she knew he had from their divorce. She had long been insisting to Mary Sue that she knew the two of them would get along.

"Susan kept saying, 'Oh, I wish you could meet my ex-husband. You two are perfect for each other!' And it was funny, because when he came out to design the restaurant, I certainly anticipated liking him—but not falling in love with him. Not that at all. He came out and sat at the bar at City Cafe and ordered a salad. He sent word back to the kitchen to tell Susan that he was there. I remember looking through the door of the kitchen, checking him out, wondering what he was like."

Mary Sue turns to Susan. "When it started to happen, didn't you think, 'Oh my God, I can't believe it?'"

"I don't remember thinking that. I never felt weird about it, but that was . . ."

"Five or six years after the divorce."

"Right," Susan nods.

By then she'd told all her friends that she was gay and was deeply committed to a relationship

"I was in such a different place. It wasn't like I was with another man."

"But you know, I think all three of us were open to how it would turn out."

What frightened them most was that the relationship between Mary Sue and Josh would end badly and somehow

affect the friendship—and by then, business partnership—between Mary Sue and Susan.

"We were probably more aware of that later," Susan says.

"Yeah, we were pretty naive. Very young."

"Yes," says Susan with a laugh. "It took years of therapy to realize—this is verrrrrrryyyy complicated!"

As surprising as it was that Josh and Mary Sue fell in love, married, and had two sons was the fact that he and Susan, who had known each other since the fifth grade, could develop such a profound friendship. Meanwhile, the women's relationship not only survived—it thrived.

"I don't know quite why," reflects Mary Sue, "except for the fact that we're not threatened by each other at all. It never really felt like anything divisive, nothing but supportive. It's more like family than any girlfriend relationship."

"You know, it's almost hard to compare our friendship to any other relationship in our lives because we share this huge bond," considers Susan. "We've worked together for so long and we're both so passionate about our work that even with all the people you may be close with, you just don't share the same depth of understanding, of trust."

They are in Mary Sue's kitchen now, Susan digging through the refrigerator, throwing out things she's certain Mary Sue doesn't want. They pull together what's left—hard-cooked eggs, mayonnaise, chicken, mustard. There is a familiar rhythm to their work, with Mary Sue gliding calmly around the kitchen and Susan frenetically chopping and tossing. The result is collaborative, inventive, and fun: little plates of liver pâté, baba ghanoush, chicken with Dijon dressing, hummus. The air smells of ginger. There is the jangle of the telephone, the startling cry of Mary Sue's newborn son Kier, and the sound of their voices talking in old friendship code—word fragments that make sense in ways only they understand.

They interrupt and finish each others' sentences, their words colliding midair over plates of ingredients which are nothing special, just odds and ends, but which have been transformed into exotic dishes with unexpectedly delicious results—great food that satisfies the stomach and nourishes a friend's soul.

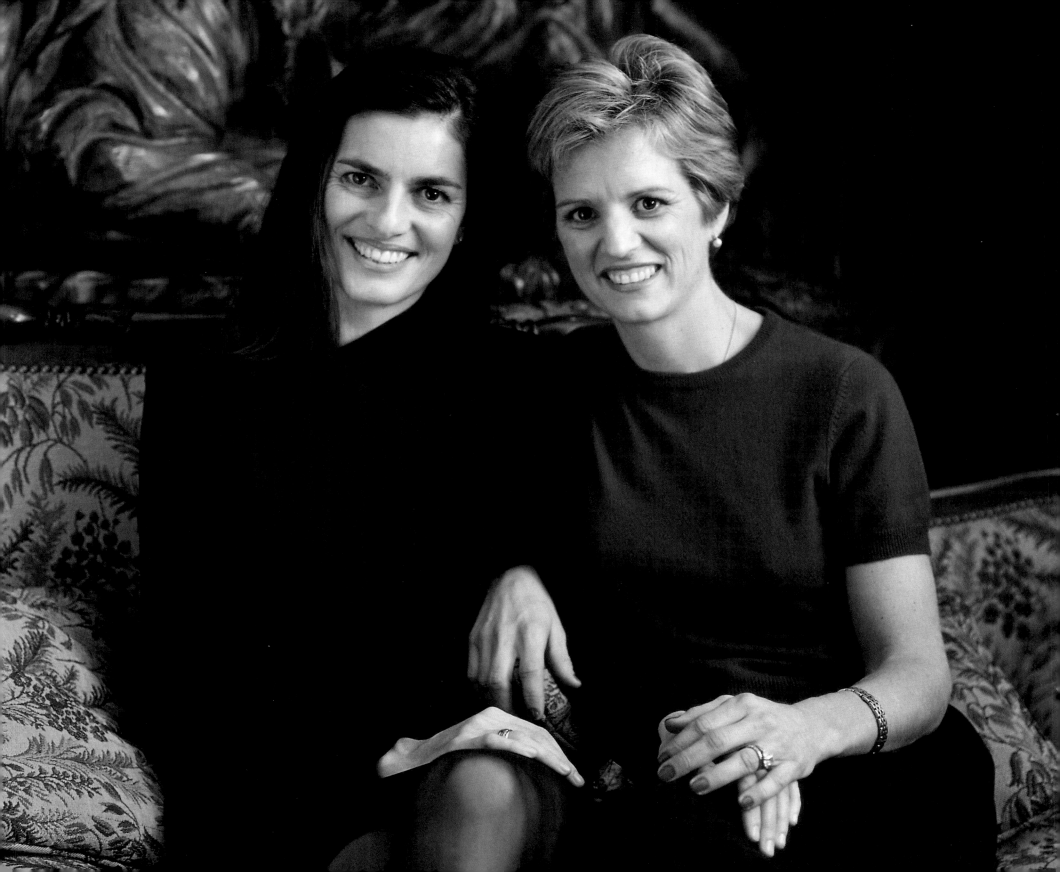

kerry kennedy cuomo
and mary richardson kennedy

*Mary Richardson Kennedy (left)
and Kerry Kennedy Cuomo
at the National Arts Club in New York.*

"i can't tell you how great this has been," says Kerry Kennedy Cuomo of her closest friend. "Not only do we share everything we have as friends, but we get to spend holidays and vacations together, and to watch our kids grow up together. Of course, I'd always have loved her children, but if she hadn't married my brother, I don't know that we'd have so many opportunities for this incredible closeness."

To the age-old maxim that friends are friends and family is family and mixing the two can bring only grief comes the story of Kerry and her best friend, Mary Richardson Kennedy. They were friends for years when, unexpectedly, Mary and Kerry's brother Bobby fell in love, which might get in the way of some friendships—or at least complicate them considerably.

"It really is interesting," Kerry says, "because with some people, you could assume there would be mixed loyalties, and at some point you'd either have to be honest with your brother or your best friend. What do you do if there's a conflict?"

"We are so incredibly lucky that there isn't," Mary responds. "The friendship has only grown."

They first met at the Putney School, a small, progressive boarding school in Vermont where the students were hardly pampered—they raised their own food and cared for the farm's animals. Kerry and Mary were destined to be friends, they like to say, because they were just about the only two practicing Catholics at the school.

Their years were filled with adventure—weekends in Boston where Kerry's brother Bobby was studying at Harvard, or on a river-rafting trip down a previously unexplored river in Colombia, with Bobby and his

brothers David and Michael at the helm. Kerry was the more adventurous of the two. She taught Mary to drive, cut Mary's knee-length hair (Kerry and her sister blindfolding Mary and each clipping from opposite sides). Once, in a rare switch of roles, Mary proved more daring, coaxing Kerry to jump out a dorm window into a huge snowbank. The result was disastrous: Kerry broke several bones—which she teases Mary about to this day.

Over time, first at Putney, then at Brown University where they would be roommates, and later sharing their first post-college apartment, they built a friendship that ripened because of the values they shared—but especially because they had such different interests and became windows for each other into worlds they otherwise might not have seen with such passion and depth.

"That is one thing that is wonderful for us," Kerry says. "Wherever we would go—and we traveled so much together—Mary would bring this incredible love of art and architecture. She opened my eyes to culture and ballet, whereas my instinct was toward politics and people."

"We learned so much from each other," Mary says.

In 1990, Kerry fell in love and married Andrew Cuomo, who would become Secretary of Housing and Urban Development under the new Clinton administration. For the first time, Mary's and her paths diverged: Kerry, an international human rights attorney, moved to Washington. Mary became an architectural designer at a prestigious firm in New York.

She missed Kerry terribly. Even though they spoke often on the phone, they were at different points in their lives. Marrying Kerry's brother Bobby was the last thing on Mary's mind.

Then one day, Mary ran into Bobby at an art opening for a mutual friend.

"There were five hundred people, all dressed in black," Mary recalls, laughing. "Bobby didn't know anybody, so he made a beeline for me from across the room. He felt totally out of place."

No one was more surprised than she was when, soon afterwards, Bobby asked if she'd consider dating him. By this time, he had been married and divorced with two kids.

"I just hadn't looked at him that way—until that night," Mary explains.

It seemed impossible that, of all the men she'd met, she'd end up falling in love with Bobby, whom she'd known for so long as the big brother of her best friend. She worried about jeopardizing her friendship with Kerry, and the brother-sister relationship that was so important to her friend.

Faced with the prospect of telling Kerry, who knew just about everything in her life, Mary stalled. A week went by, then another, and another.

"I felt so torn," Mary remembers. "Was I nervous? I was terrified!"

Finally, she and Bobby made plans to meet Kerry at a conference. The day of reckoning had arrived.

"I kept looking around to see where he was and then he was

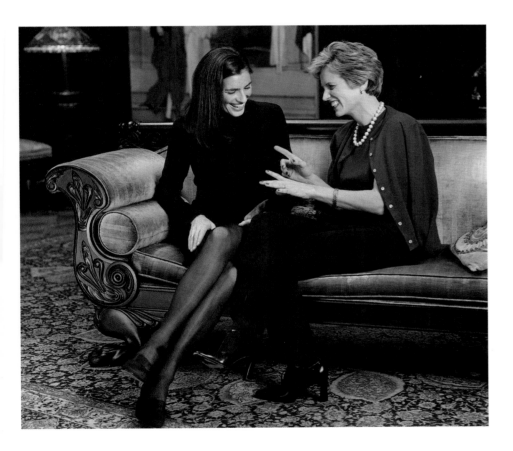

finally gone and I thought, Phew, I'm safe. The next thing I know, Kerry was running up to me with this big smile, saying 'This is so great!'"

Bobby wanted to tell the world about their relationship.

"And why not?" Kerry insists. "He had found the most incredible woman in the world!

"You have to understand," she continues, "Bobby and Mary had a friendship that was independent of my relationship with her, long before they became sweethearts. So when they told me, I was just over the moon. They were made for each other."

As their own families grew, Kerry and Mary drew even closer, sharing occasions and events that are devoted to just family.

"A relationship with a best friend can even be better than with a sibling," says Mary. "You have no competition, no sibling rivalry—none of the mixed emotions. It's so strong because you've chosen it."

"There's something else that goes back to that theme of being voluntary," Kerry says. "With any relationship you know you can be very close, but there's an expectation that defines it. With Mary, there are no boundaries. There is just a sense of love and support, loving everything that you gain from each other.

"I think of this in an almost religious sense—of responding to why we are put on earth and what God has asked us to do. It's about trying to find good in one another. That is so clear to me in everything Mary has been about."

Mary, eyes watering, blinks hard. "Wow," she says simply, looking at her sister-in-law. "Thank you, Kerry."

melissa behr
and sherrie rose

Melissa Behr and Sherrie Rose gaze out the window of their parked Winnebago as if something is passing them by. There is only the setting sun and the animal quiet of daytime on Sunset Hills' outer edge. But being still was, for most of their lives, not in their natures. They were best on the move—leaving homes, families, and relationships behind.

That was before they met each other. Now they have a publicist, an agent, phone calls to return, two motorcycles, a shiny Lexus (just to keep people guessing, they joke), a Winnebago, and most important, their shared improbable success. Together they made a film—*Me and Will*. They wrote the script. Raised the money for it. Directed and produced it together. And though the film has not yet been picked up by a domestic distributor, it is slated to kick off the Sundance Channel's *She Said Cinema*, and creating it has changed the way they view their lives.

"The film is about our friendship," Sherrie says. "When we met we had followed so much of the same paths, and I think that's what drew us to each other, these tortured pasts. But then it was like our paths were so close you see the pain and recognize it."

Melissa nods. "We both helped each other grow up. Together we could face things, instead of hiding, hiding, hiding."

Melissa Behr (left) and Sherrie Rose share the afternoon sunlight in their Winnebago.

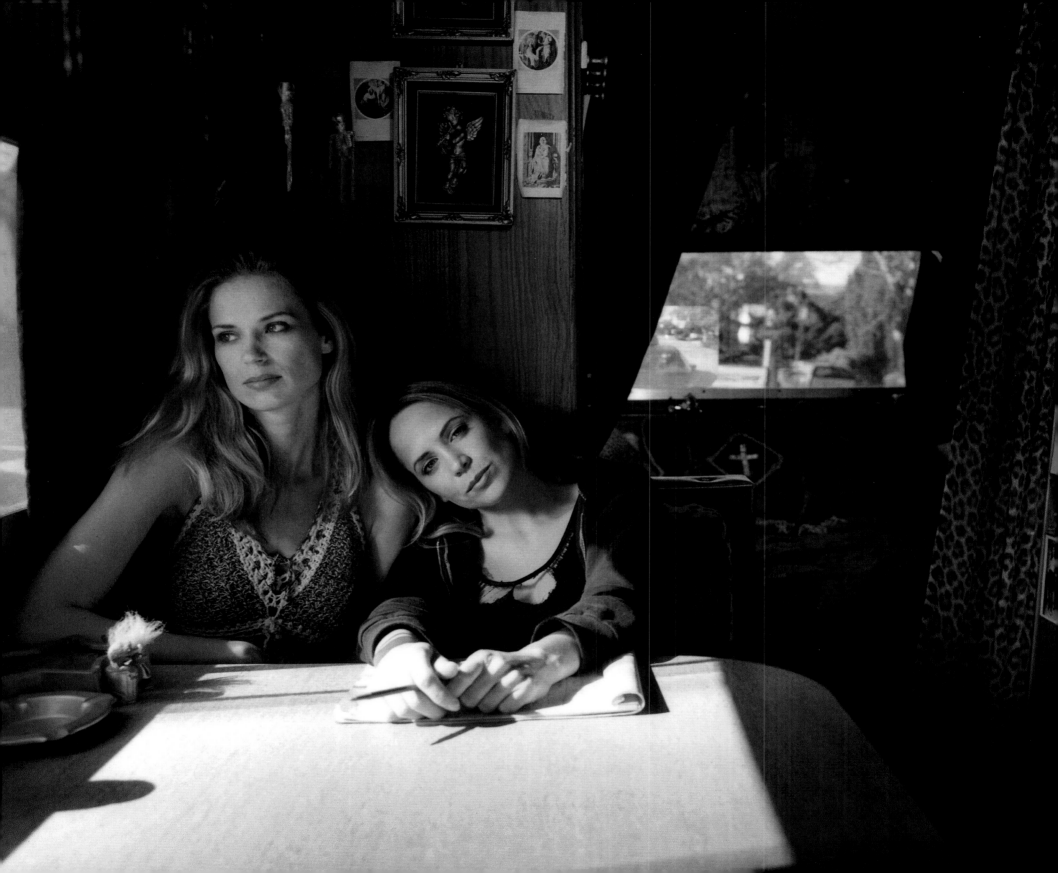

the film is an unfiltered look at the lives of two women, drifters, who never latch onto anyone or anything for very long, except drugs and alcohol. They crash-land in a rehabilitation center, where they meet and come up with what strikes them as the perfect pursuit: to find the original motorcycle used in that seminal road film *Easy Rider*. The movie follows their bid to find the motorcycle and unravel the demons that drive them.

This is not to be confused with their own story, which is that of two drifters who met in the Hollywood club scene in the late eighties. They had much in common: both rode motorcycles, knew life on the run, and used drugs to help them leave their lives behind. When they met through a mutual friend, they saw in each other something instantly recognizable—not only who they were, but what they had been trying to express.

"Sherrie goes, 'Oh, I always wanted to write a movie about girls on bikes.' And I'm like, 'Yeah!' says Melissa. "Years went by and we talked about it and talked about it, and finally we sat down and wrote it."

She affects a look of mock skepticism, realizing theirs sounds like the oldest story in Hollywood, the cliché of "Hey, let's make a movie." Who wouldn't have put a million-to-one odds against their pulling it off? All they had were a string of odd credits from obscure films, commercials, modeling, and photography—and nothing to lose.

"Before, it was like whenever life got complicated, I just wanted to run away," Sherrie says. "And when we first started

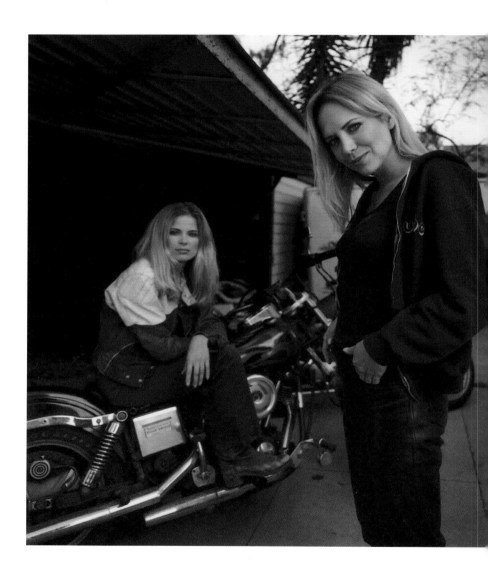

the film, something would go wrong and I'd be like, 'Fuck it. I'm just going to get high or run away.'

"But then we got sober, and we began to lean on each other," she continues. "For the first time, I didn't run. We rode out the bad times. We learned about each other. We allowed ourselves to be vulnerable, to experience our feelings and be gentle, as opposed to just shutting down."

"The film became more realized as our friendship did," Sherrie explains. "We'd like to go off on trips with no money, and crazy things would happen and then it would become part of the script. Once we took our bikes up to San Francisco and we didn't have enough money, so we snuck into a hotel . . ."

"It was a pretty nice hotel," Melissa adds.

"So we snuck into the hotel and slept under the stairs."

"And then the vacuum people came in the morning, and we're like, oh my God, the vacuum people are here . . ."

They're laughing hysterically by now, remembering that Melissa was carrying a gun—as if she wanted to keep them safe from the cleaning crew.

There they were, still running, but this time not alone.

"We couldn't have done it without each other," Melissa says emphatically. "Just having each other there, saying, 'Don't let the bastards get you down. Just keep going.'"

"We felt like we had something to say," says Sherrie, "and we felt like we knew how to say it."

They worked all day, partied most of the night, and revised the script three or four times, writing mostly in a drugged fog.

But as Sherrie and Melissa pushed each other to get sober, the work began to take shape. Strapped for cash, they decided to make the Winnebago, where Sherrie sometimes lives, part of the movie set. The difficult part, they knew, would be convincing financial backers to take them seriously.

"Meeting the people who have the money—that wasn't the hard part," says Sherrie, rolling her eyes.

"That's Hollywood," adds Melissa. "Meeting guys is easy. It was getting them to give us the money."

"We'd meet them for lunch or dinner, and present our package," explains Sherrie. "Our joke was that they'd always say, 'You have to meet my other friend. This is the guy who really deals with making movies. So bring your package tomorrow night and we'll talk about it.'"

When backers showed interest, there was always a catch— the story had to revolve around lesbians, or car crashes.

Eventually, they scraped together the money they needed, and *Me and Will* got made. Their agent says they turned down offers of more than a million dollars to turn the film over to someone else. Why?

"Because it was so close to our lives," Sherrie says, simply.

Melissa agrees. "We're not big on letting anybody else control us," she says.

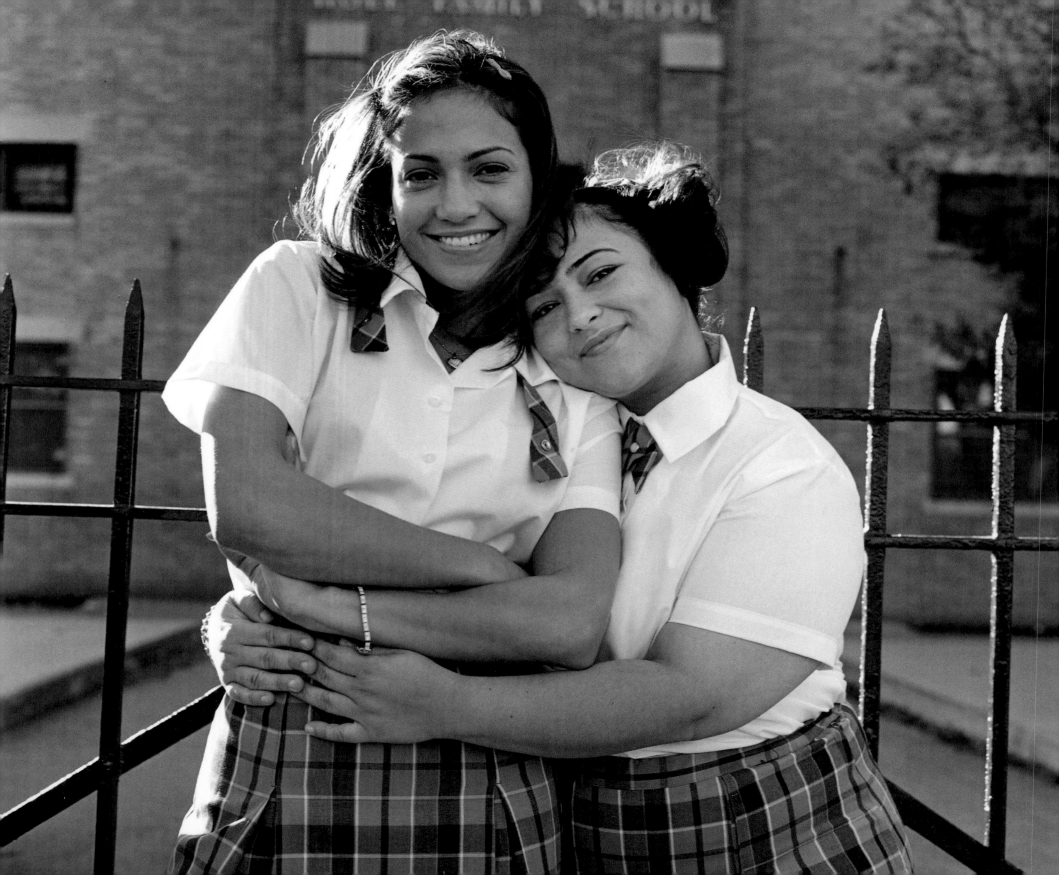

jennifer lopez *and* arlene rodriguez

Jennifer Lopez is shooting *Blood and Wine,* when Jack Nicholson comes up to her and says, "Where's your girl?" The "girl" in question is Jennifer's best friend, Arlene Rodriguez. She's also her personal assistant, though she's only been in that role for a week. But already, someone as important as Jack Nicholson is looking for Arlene, which Jennifer figures must be a good sign. As it happens, Jennifer doesn't have a clue where Arlene is but she can't tell Jack Nicholson that. So she says, "Um, she's getting me coffee."

"I don't think so," says Jack. He points to a tree in the distance.

Curled up beneath it is Arlene, sound asleep.

"Ohhhhh," groans Jennifer. She walks toward Arlene, her lifelong best friend, the person she trusts more than just about anyone in her life, who is now the person she just might have to fire.

Jennifer and Arlene have been through everything together—Catholic school, puberty, first dates, Jennifer's first audition. But when she seemed to come out of nowhere to win the role of *Selena,* the Latina singing legend, Jennifer was suddenly launched into a world few understand. Within a few years her name would be everywhere—opposite George Clooney in *Out of Sight,* Jon Voight in *Anaconda,* and Woody Allen in the animated movie *Antz.* She was a young star with an agent, a publicist, and the buzz afforded those headed for superstardom. What she did not have was a personal assistant. Her head told her to consider someone experienced at the job, someone well-versed in the idiosyncrasies of Hollywood. Her heart told her only one person would do—Arlene.

53

At the time, Arlene was working in a video store in the Bronx and, upon hearing her friend's offer, figured, why not?

But that first day on the job, Arlene remembers thinking, *What am I doing here?*

"It was all very strange for me," she says. "I was homesick. The atmosphere was very, very different, and the thought of getting up at five in the morning was unheard of. Little by little I got used to it, but that first movie was really hard."

"When you start working with a friend, you're riding a very thin line," Jennifer says. "This is your friend, but she's also an employee. She'd say, 'I don't understand what you need.' And I'd say, 'I can't explain it any better.'"

For more than a year, Jennifer and Arlene tried to find a delicate balance, a place where their professional relationship didn't conflict with the personal one.

"There came a time when we were thinking about not doing this anymore," Jennifer admits. "Things had gotten really strained. So I told her that she should go back to the Bronx and see if she wanted to be there."

Arlene says she always knew she'd return to Hollywood to be with her friend. But Jennifer wasn't so sure.

"We're like family," she says. "It's like saying to your family, 'I can't work with you anymore.' But it's worse because it's somebody you love hanging out with. It's not like a sister who you know isn't going anywhere."

For weeks, Jennifer stopped herself from calling Arlene.

"Finally I called, and she's like, 'You haven't called me!' I really wanted to give her space to figure out what she wanted.

I said, 'I didn't know if you were coming back.' She's like, "Of course I'm coming back.' We both had things to learn." For Arlene, that meant a fuller comprehension of her job. For Jennifer, it meant learning to communicate, to explain to Arlene the ways in which Jennifer's work or reputation could suffer if Arlene didn't understand her job. At the same time, Jennifer struggled to hold on to the friendship.

"I felt like I was losing my best friend," Jennifer says. "I had to understand that there were times when she needed to get away from me and have her own social life, to feel like she wasn't working all the time. Now we know how it meshes."

as kids, they slept at each other's houses, made up games, played charades and cards. Their memory of those years is not of growing up with the particular hardships and pressures of the Bronx, but of sheer giddiness—being with someone who makes life fun.

"We're not like everybody else," Jennifer says. "On the set, you have all these people and their entourages, everybody acting a certain way, talking a certain way, and then we show up and they're like, 'Where did these two come from?' We're two little girls from the Bronx, exactly the same as we were in second grade."

"You know how I met her?" says Arlene. "She kicked me. She did. She told me she was pretending to be Pinky Tuscadero [Fonzie's legendary hard-edged girlfriend]."

Jennifer harrumphs. "I *was* Pinky Tuscadero."

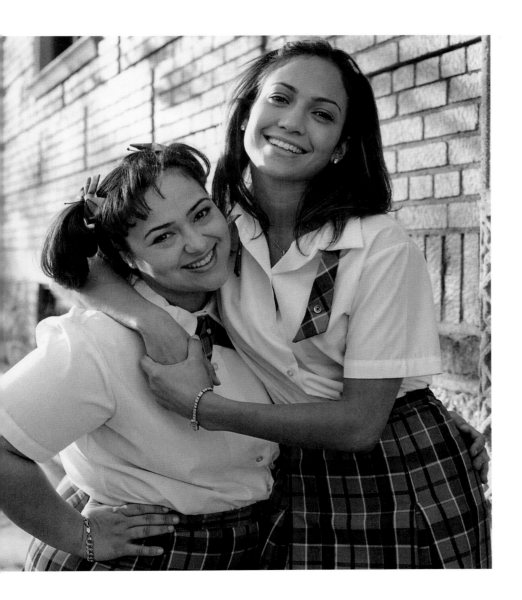

Today, their best moments are most often private ones, such as reading Jennifer's fan mail, flying the Concorde to Paris, or riding in a black stretch limousine, giggling and screaming because neither of them ever imagined they'd be where they are.

Jennifer is finishing her first album, choosing between film offers, and imagining ways to inspire kids with backgrounds similar to hers—kids who identify with Selena, the music icon who died so young, as well as with Lopez herself.

"I can really accomplish something. Not necessarily as an actress but as a voice in the community," she says. "You want to be conscious of the fact that you have an effect on people. When you realize that, you say, 'What can I do? How can I help?' And one of my goals is to form a foundation to give kids hope. I think in just seeing someone like me, they get inspired to do something. That alone makes me want to do the best work I can do. We believe we're making an impact. And I say 'we' because Arlene's right there by my side."

For Arlene, that's only part of how her life has changed: visiting places like Venice, attending Hollywood parties, but most of all, watching her best friend turn into a film character, suddenly real and alive.

"To watch her make *Selena* was amazing," Arlene says reverently. "She wasn't just acting. She *became* Selena."

Hearing this, Jennifer exclaims, "You never told me!"

"I never told you?" Arlene says. Then shrugs. "You knew."

"See?" Jennifer says. "She doesn't tell me how well I do. I don't tell her what she means to me. She knows."

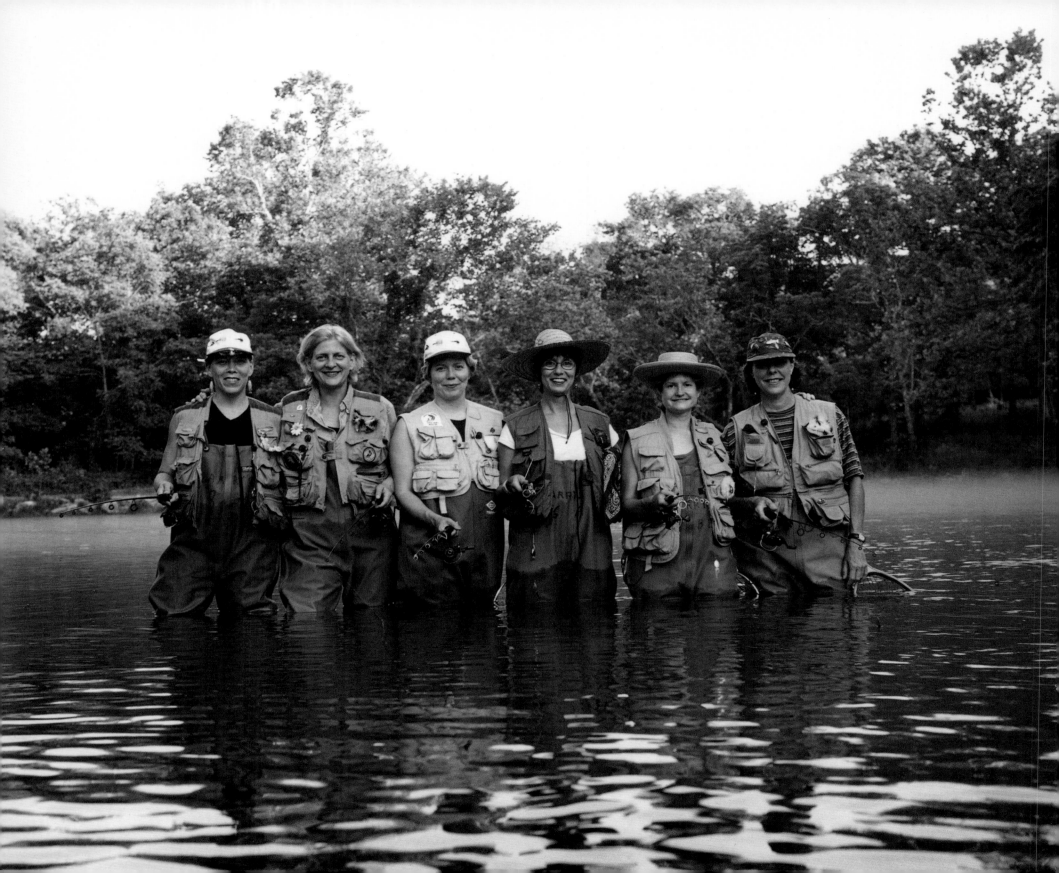

lisa tully dibble
emily eddins
zola k. gordy
franny o'gorman
martha schneickert
and m.j. van de castle

*Lisa Tully Dibble, Franny O'Gorman,
Emily Eddins, Zola K. Gordy, M.J. Van de Castle,
and Martha Schneickert (left to right), waiting for
a catch in Bennett Spring, Missouri.*

every year, on the last weekend in May, six friends leave behind their work, their families, and the clutter of daily life to spend three days on a trout stream deep in the Ozarks. It is a place they found nine years ago when, on a lark, two of them decided to learn how to fish.

The women headed south of Kansas City, where they'd all first met, to the mountains, where urban landscapes give way to great rocky cliffs and canopies of trees. Running north to south was a rich trout stream. There, they found a place to stay called Larry's Cabins, where they are now known and welcomed each spring. On those early excursions, however, they were regarded with caution.

For one thing, they were women fishing alone. For another, as Larry will tell you, they didn't exactly know how to fish.

But fishing was then, and is still, beside the point. The point is to come to this place, away from the world that rewards them for what they do, and be with friends who reward them for who they are.

57

"This is three days just about us," says Frannie O'Gorman, who lives in New York and looks forward, all year long, to this weekend outing. "It's this chance to get out of our lives and just enjoy each other without the husbands and the extraneous stuff, this consolidated time to be with your girlfriends and laugh and have a good time."

even on that first outing, they weren't after the fishing trip of legend and literature, that famously Hemingwayesque domain in which men plumb the river's depths and the hauntings of one's soul. They just wanted to do something together and have fun.

Frannie, for instance, is a vegetarian who recoils at the sight of fish guts. She stands in her waders, cigarettes at hand, lipstick in her front pocket, cheering on her friends and hoping she doesn't feel anything tug on her line, a sort of anti-fishing pursuit of fish.

At no time is there silence. They are talking now, though it's barely dawn, though others who are fishing—men, mostly—eye them disapprovingly and move downstream, away from them.

"Don't you think it was fun at first because it was female bonding in a male sport?" asks M.J. Van de Castle. The youngest of the group at thirty-nine, she's a hairstylist who owns and operates a spa.

"It's like a big slumber party—this incredible time together," says Martha Schneickert, who a year ago left Kansas City for Portland, Oregon. "I laugh more here than I do all year!"

58

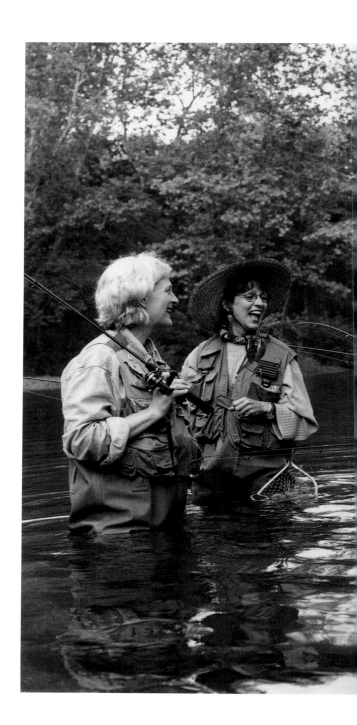

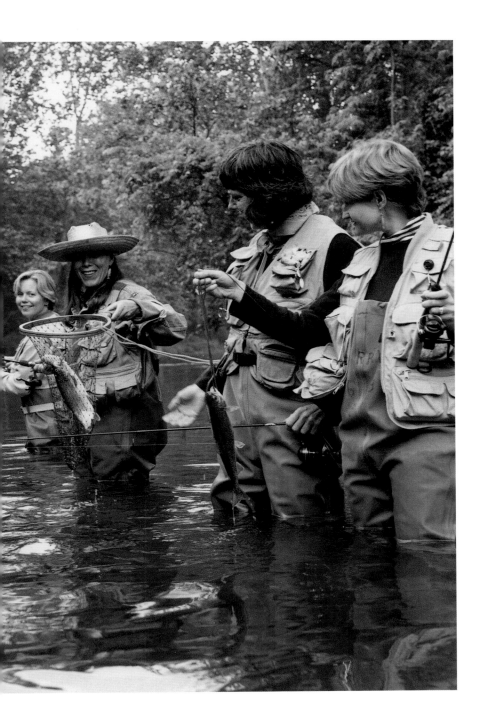

"We've gone through a lot of life issues together," says Zola K. Gordy, whom they call "Kitty," the one in the Tom Sawyer-esque hat. "Every one of these women is so different and inspires me in such different ways. The issues that each of us brings are always different. One year it was Frannie's mom dying of cancer. Another year it was Lisa having a baby. What we talk about is always changing."

"Sex, no sex," someone says.

"Men, no men," says another.

"Children, no children."

"Dogs, no dogs."

For the purposes of this group, trout is merely the impulse behind what have become the rituals of celebration. There is the traditional exchange of gifts, which must be done upon arrival at Larry's and must be done with Champagne. There are the year-long preparations—the phone calls, e-mails, annual meetings. After nine years, they have the planning down to a science: lists and more lists of food, liquor, supplies, expenses are kept on computer. Tasks—who brings the board games, who brings the music—get divvied up. Always, they bring the all-important journal—a blue binder they call *Trout Talk* in which they take turns writing down thoughts and memories. The first entry for this year is a letter from Emily Eddins, which they all waited for and welcomed like a long-missed friend.

Dear Sisters,

Ah, the great outdoors, the fresh air, the camaraderie of friends, leaving behind the stress and hectic pace of our daily

59

routine. Once again it's that time when we pack our bags,
fishing gear, food, alcohol and whatever other substances, with
the faith that this year we will catch enough fish for at least
an appetizer. . . .

Circumstances permitting, moist, delicious fresh trout may appear as the main course at dinner. Evening meals are elaborate events, served alfresco, with tablecloths and plates that are not paper. There are real forks and wine glasses tied with ribbons of different colors so they don't forget which glass is whose.

Then, of course, there is the occasional capture of a fish. Like everything else, it is always a communal accomplishment.

"OHMYGOD. OHMYGOD." It's M.J., with something on her line.

Lisa Tully Dibble and Martha move gently toward her, nodding and coaching as they go: "Bring your line up. Roll it in, easy. Don't jerk it." They're the two fishing experts, the ones most likely to clean and gut the trout.

"I'VE GOT ONE." M.J.'s nearly jumping for joy.

Frannie, the catch-and-release pacifist, abandons her rod and heads for the camera.

"Relax, M.J.," Emily advises. "Now, pull back on your rod."

Frannie is clicking the camera with one hand, waving her cigarette with the other. "Here. Look over here."

"Just keep reeling, M.J.," Lisa says

"I AM!" M.J. cries with a what-do-you-think-I'm-doing? look. Then, as if in shock, she says, "WHERE IS HE?"

Lisa peers through her glasses at the water, now still. "I don't see him," she says.

M.J. is frantic. "HE'S GOT TO BE THERE! GET SOME GLASSES!"

And then, there he is, Mr. Trout doing flips in Lisa's net as Lisa salutes and Frannie is clicking her camera, laughing hysterically, saying, "How does it feel, M.J.?" Lisa is repeating what will become M.J.'s famous line from that trip, "Get some glasses."

"You're telling me to get some glasses?"

And then, they are all laughing, posing for a picture, applauding M.J.'s fish. Life's great catches often come like this, unexpectedly, they say later as they're preparing dinner. Emily and Kitty grill the trout, toss coconut rice in a wok over the coals, and dish out marinated eggplant. Frannie, Lisa, and M.J. pour wine, and then more wine.

They will joke and tell stories and feed each other lines until finally they are full. All around them is the sound of locusts, which have been dormant for seventeen years and are now hatching wildly. They make a throbbing hum in the night, a noise that in Kansas City or New York or Portland would be barely audible.

But here, the sound feels strong enough to touch. They'll record it and keep it in their memories in the long months ahead, when they are so busy with real life that they can only catch each other's friendship on the fly.

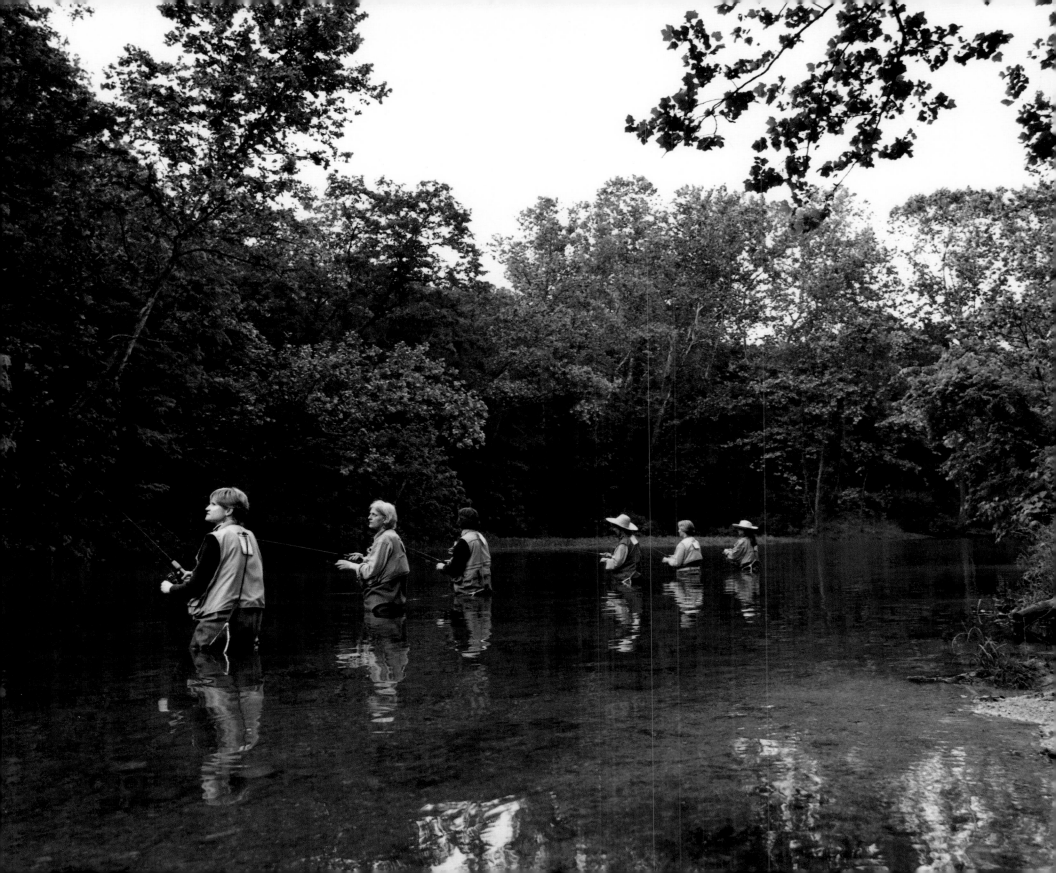

lisa collins
and kimberly hayes taylor

When Kimberly Hayes Taylor and Lisa Collins first met, neither thought, *Here is the person who will show me a world I need to see.*

Kimberly, who grew up in Louisville, Kentucky, was thirty-six and a journalist for the *Minneapolis Star Tribune*.

Lisa lived in an edgy neighborhood of Minneapolis, where success as a kid meant belonging to a gang and wearing high-priced jeans. She was a quiet thirteen-year-old who did very well in school and loved to read. But she found it nearly impossible to confide in anyone, even herself, about what she really thought.

"I don't think I knew this, but I had way low self-esteem," recalls Lisa.

One day Kim was assigned a story that took her to Lisa's classroom. She wanted to interview the kids in Lisa's class to find out if they were failing a particular standardized test because of pressures outside school—poverty, violence, family problems.

Kimberly Hayes Taylor (left) and Lisa Collins

Kim barely noticed Lisa at first, even though she'd taken a seat right behind her in the classroom. Even then, compared with her classmates, Lisa seemed invisible. She hardly said a word. She was skinny and tall, but always hunched over as if hiding herself. Kim was drawn to her because of what the teacher said—that Lisa, for all her silence, was a girl who had much to say. She was smart and had great promise; she faced the same pressures as all the other kids, but succeeded anyway.

One day Kim asked to read Lisa's journal. And as Kim flipped through the pages, she discovered a girl whose spirit moved Kim, a girl whom Kim wanted to know.

Kim finished her story, but the friendship with Lisa had just begun.

The result is a unique relationship that isn't defined by what so many friends typically have in common—age, values, background, seeing life unfold from the same place at the same time—but by their mutual drive to make something better of the world and their lives.

"My other friendships were usually with women who were in the same profession or the same age, and you think, 'Oh, we're so tight.' But it always seemed like something got in the way—maybe jealousy or competition, I don't know, or something that made you ask yourself, 'Does this person really have my heart?' But with Lisa, it's like, she takes me into her world, and shows me things I wouldn't have ever seen. And I think I do the same for her. Isn't that what friendship is really all about?"

Kim is robust in spirit and energy—seemingly able to do anything.

Lisa, thin and birdlike, still speaks with some hesitation. "Before Kim, I never really had anybody to talk to," she says. "I hated the way I looked. I didn't tell anybody. Not even my mom."

"Isn't it funny?" remarks Kim. "See, she's got all this beauty, and she thinks she's too skinny. I'm always saying I'm too fat. We just need to put us together."

It is, in a sense, what defines their friendship. Together, they say they have an identity that is better than what they'd have by themselves.

"I think there's a tendency to look at a friendship and look for its defined edges," Kim says. "You say, 'Oh, Kim must be a mother figure for her, or a mentor,' as if age is what matters. And it's true I'm probably both those things to her. But Lisa's seen things in her fifteen young years that I never saw at her age. In a way, she has a handle on the realities of the world that I never had. I was a teenager who only knew things like, 'Keep your dress down.'

Now, Lisa is able to show Kim a whole new perspective on being a teenager. "I'll ask her, 'What do you hear kids saying?' Or, 'Why do they act this way?'" says Kim.

As she explores Lisa's world, so Lisa has been exposed, with Kim's encouragement, to literature, film, jazz, and other forms of culture. "I've been reading a lot of Toni Morrison," says Lisa. "Kim's showed me that I can write, too. Before, I'd think maybe I can be a journalist someday. But then I'd say (to

myself) 'forget it.' I didn't even know what a journalist was. I didn't know it was something I could ever do."

"Sometimes I'll take her to hear poets," explains Kim. "But we also do just friend stuff, like go shopping. One time, I was giving a party, and I was so nervous, I was a mess. Lisa came over and settled me down. She gets me to laugh at myself because I see things from her viewpoint, in a whole new light. That night, she helped me get everything together, and was, like, 'Here's how you're gonna do this.'"

The world Lisa lives in is one Kim might have seen anyway, since being a reporter allows her access to other people's lives. But a friend, she notes, takes you one step beyond curiosity or voyeurism. It's as if you're with each other when you're not there—hooked in the soul, as they once heard it described. It's a phrase that feels just right to them.

Sometimes, Lisa says, she thinks of how much older Kim is and wonders if they'll always be the way they are now.

"I think a lot about how four years from now I'll graduate and I wonder will she be too old to want to do the stuff we're doing now?"

Kim laughs. She sees in their age difference some limitations, but never imagined that Lisa would worry that at forty she'd be too old to do what they do now.

"I'll still be able to hang, okay?" She assures her. "Don't you worry about that."

What they know is that they have each other. They are not alone.

Recently they went to see a film together, *Free of Eden*.

It tells the story of two people, a child and a mentor, and how their unlikely friendship changes both their lives. It is a tale that had particular resonance for both of them.

Lisa, now fifteen, will spend the next year in a program that allows high school students to work as reporters at the *Star Tribune*.

Kim, meanwhile, continues to report and write about neighborhoods like Lisa's and about how the circumstances there shape residents' lives. And just as Kim took Lisa to poetry readings and films she might not otherwise see, Lisa convinced Kim to accompany her to a modeling class. Lisa signed up for it thinking it might help her feel better about being tall and thin. Kim went along, with no intention of participating, but ended up joining Lisa in the spirit of the moment.

Because of Kim's friendship, Lisa says she's been able to explore what she is most frightened of, to talk about what she most wants to hide. "The other kids in school, they don't understand. Or you tell one person and then everyone knows. But with Kim, it's like she's the first person I can really trust."

Kim is quiet for a moment. "I never knew that," she says.

"Yeah, well," says Lisa. She spreads her hands on her jeans, studies them, then looks up. "I was gonna tell you. Anyway, I feel like that."

robin arundel
kristie bretzke
lisa m. brown
kristie harrison
mickey o'kane
and patti h. soskin

Kristie Bretzke, Lisa M. Brown,
Kristie Harrison, Robin Arundel,
Patti H. Soskin, and Mickey O'Kane
(left to right) ride—and sail—in style
near the Island of Happy Days.

i

In the annals of women's friendships are endless stories of women on the road. This story is not about ordinary women—nor about ordinary cars.

The cars are called amphicars—so named for their unlikely ability to move on land and water. They are also exceedingly rare: of the some thirty-seven hundred made in Germany between 1961 and 1968, about four hundred are left.

But then the women—who call themselves amphiauxiliary—share a friendship as unique as the cars that distinguish them. They are together a lot: for riotous meetings, outrageous costume parties, any excuse to have not just fun, but thrilling fun.

"There is this kind of magic when we're together, this guaranteed good time," says Kristie Harrison. "We have our own language, our own history."

At the core of their friendship, she says, is the commitment to go everywhere together. "We always travel in a caravan, and if one stops, we all stop; we're only as strong as our weakest link."

There was a time, as Patti H. Soskin will tell you, when the women were "all normal once," when their friendships revolved around phone calls and meals out, books, clothes. "We looked at these cars probably the way you do," Patti notes. "As a stupid, ridiculous waste of money."

For the record, they are lousy cars. Bad on land, worse on water, they are expensive to maintain, temperamental to the touch. In the eleven years since they were bought, the cars have been in the shop so often that the group's mechanic invited them to his wedding. Were you to take your closest friends and buy anything to distinguish you, there are probably a million choices that might be more prudent.

But to say this friendship is about cars is like saying *Thelma and Louise* is a film about a road trip.

67

For all the implied momentum, the cars have become something that stops time, that stands for them as a concrete reminder of friendship's buoyancy—of its uncanny ability to keep you afloat when the worst of life seems destined to drag you down.

"The car is what's constantly bringing us together," notes Mickey O'Kane. "It's like a symbol at the core. We would be friends without the cars. But we wouldn't have so much fun."

At the moment they are at Stout's Lodge, a favorite getaway on the Island of Happy Days, not far from Minneapolis, where they all live. They are talking about the days when Patti—the last to join—bought a car. She'd been friends with some of them and figured the car would make her an automatic member. Not so.

"We put her through a long, long initiation," recalls Mickey.

"We made her memorize all the parts of the car," says Lisa Brown.

"And then I had to write a speech about why I wanted to be part of the group," Patti recalls, laughing.

"It was touching," Mickey assures her. "Truly touching. Of course, the only reason we let you in is because you are, in fact, younger than the rest of us, and we plan on having you take care of us in our old age."

What distinguishes them, they say, is not just the car, but the fact that they have true admiration for each other's husbands, who are close friends, and children, who have grown up together. "It's like this incredible extended family, where everyone gets along," notes Kristie Bretzke.

"But it's more than that," says Patti. "I think of you guys the way I think of friends I've had since I was three—as my lifetime friends."

"Friendships don't just happen," says Mickey. "It's being together again and again, caring for the details in everyone's lives.

"We don't talk every day," notes Kristie, "but not much happens in our lives that we don't talk about."

"The only way I can explain it," says Lisa, "is that these women have been my support for the biggest decision of my life. Not just my support, but also my husband's." Lisa and her husband were debating whether to have a child. The more she tried to convince herself she did not want one, the more certain she became that she did. Ultimately, in 1997, they had Matthias.

"Yes, we like to think of Matt as our baby," jokes Mickey.

Though they are mostly in their forties, they talk of retiring together—of pooling dues from their meetings and finding that one perfect spot.

"The amphicars are a lot like life. They look very solid, but they're really very fragile," notes Robin Arundel.

For now, it's a perfect day to drive. They pile into one car, the sun glistening off its shiny fins. Someone waves and stands, and they all follow suit, trying for one universal salute. The car tips and totters and they are all laughing, tossed about by the waves and sunlight and the weight of all of them on one man-made contraption. Yet, somehow, together, they manage to pull off a small happy miracle. The car floats.

la keshia frett
and saudia roundtree

Saudia Roundtree and "Keshia" Frett knew just enough about each other to know that while they might end up as basketball teammates at the University of Georgia, they'd never be great friends.

Saudia had heard of Keshia's prowess on the court and had seen her on television, though she tried not watch. Keshia was a good player, possibly a great player. And Saudia didn't like the prospect of being second best.

Keshia was aware of Saudia, too. She'd heard how this great new player was going to arrive in Georgia, like a savior. As if they couldn't play basketball without her. So when Saudia actually got there and turned to Keshia and asked, in her I'll-say-whatever-I-want way, "You ready to run?" Keshia responded, "Yeah, I'm ready. Just give me the damn ball."

They were, and are, competitors first. They always had that in common. The trust came later—in their final years in college and then more profoundly when they played on separate teams as professionals.

"It took us getting away from Georgia to build this powerful friendship," says Saudia, who was, by then, a rising star, named Naismith Player of the Year—best women's collegiate basketball player—and recruited by the Atlanta Glory. Eventually, Reebok even named a shoe for

Saudia Roundtree (left) displays her defense skills with La Keshia Frett outside of Saudia's home in Lawrenceville, Georgia.

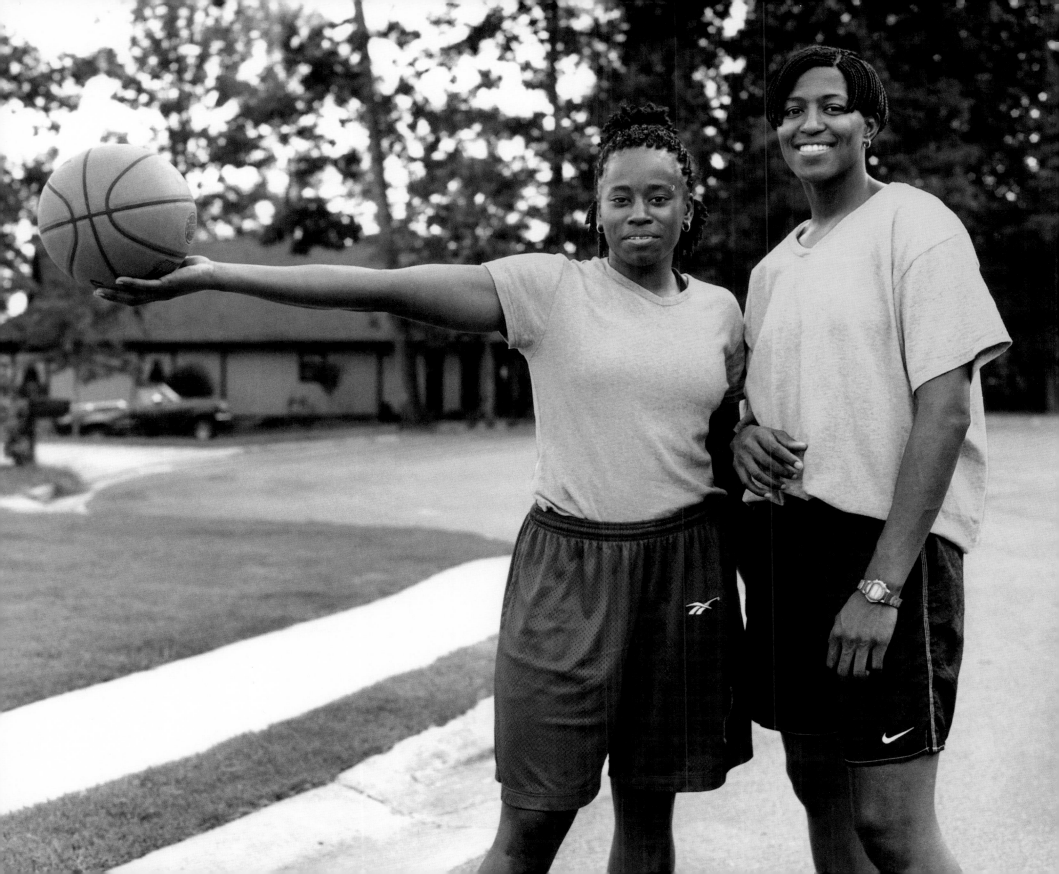

her, "The Dime" (for her ability to stop). Keshia went to the Philadelphia Rage. Both teams were part of the now-defunct American Basketball League, one of the first professional women's basketball leagues.

For Saudia and Keshia, playing professionally was a dream they never thought they'd realize. It also strengthened their bond, as they relied on each other to understand their new world.

"When I was growing up, I didn't think I'd even have the chance to play in college," Saudia recalls. "I just knew at an early age that I could dribble the ball between my legs and thought, *dang, I might play this game*. I just loved the game."

Keshia did too. But they played with boys in their neighborhoods.

"I was always a loner," says Keshia. "I don't really open up to anyone."

Saudia nods, "I never had what you'd call true friends. I just hung out with people because they happened to be there. And you know, people look at athletics a certain way—they put us on a pedestal—and that makes it hard to talk with someone on a very personal level. But with Keshia, I feel like it's genuine."

"Yeah," says Keshia. "We're competitive on the court and we can say and do whatever and know it's going to be okay. . . . There's something you feel inside when you trust someone— that you can say anything—and that's hard to find."

It is now summer, before the start of what will unexpectedly be the final months of the ABL. They see each other often,

traveling between Atlanta and Philadelphia when they can, grabbing games wherever they can. Often, these are pickup games in gyms or on streets where the players—as they were when they were kids—are almost always male. Both of them know what this means.

"It's a challenge for me," says Saudia. Keshia whistles a that's-an-understatement appreciation. "It's like anything," Saudia continues. "Men dominate the game. They think women can't do this or that. Their egos can drive you crazy. But I'm just playing because I love this game. I'm like, 'Yo, pass the damn ball.'"

They are distinctly different players. Saudia is fast, on the attack. Keshia pulls inward, putting on a game face as if to block out everything but her intention to get the ball.

"People have always judged me for how I am on the court," Saudia says. "But if you take it personal, then you've got a problem. I just don't deal with many people. But Keshia's personality is so different from mine. I'm very outspoken. I'll say whatever. But it's all about getting better. Maybe you're good. Maybe one day you'll be great. Keshia can be great— and it's because she works hard, and is the person she is."

During those first months together, playing for the University of Georgia, they were fierce competitors. Saudia ran fast, quickening the pace of the game in a way that pushed Keshia to play better. But off the court, Keshia rarely talked. Saudia would hear things Keshia supposedly said about her. Eventually, they faced each other and their perceptions directly, opening up for the first time.

"I always wanted to get to know her—mainly because it was a challenge and I'm this competitive person," Saudia says. "She wouldn't let anybody get close to her, and I knew that to figure her out—phew! That's like a puzzle."

"I had heard a lot about her," Keshia recalls. "And in time, I appreciated Saudia as a player, because of the excitement she brings to the game. She had a great senior year, and it did a lot for me."

Both grew up loving basketball—Saudia in South Carolina, Keshia as a military kid, moving from place to place. Neither imagined they'd have a chance to play professionally. Then, just as they were about to graduate from college, the ABL was starting up, along with the Women's National Basketball Association.

"Our friendship grew because we grew as people," Saudia says. "Away from college, you look at yourself in a different way. I always wanted to have that close friend, the person you could tell anything to. I don't know if that's because I don't have a sister. I'm close to my mom, but a friend can say things a mom can't. Sometimes you don't want to hear that everything is going to be okay. If I'm upset after a game, my mom doesn't understand. To her, it's just a game. She doesn't understand what's really going on inside, how the body aches, how the mind thinks."

"I used to worry a lot—what's going to happen?" says Keshia.

"Yeah," says Saudia. "You reach a point where you realize that what's going to happen is going to happen. There are things you can't control."

"But now we can talk about everything," Keshia says. "Our goals, what we're thinking . . ."

"Where we want to live," adds Saudia. "Music . . ."

At this moment, though, there is just the love of the game on a summer afternoon, before Keshia heads back to Philadelphia, and they have to face uncertainty about the future.

"If you sit there and think about how good you are or what's coming next, you'll never get where you want to be," says Saudia. "I think we just have to focus on where we are right now."

today, that is on a quiet suburban cul-de-sac outside Saudia's house, in Lawrenceville, Georgia. The only audible noises are their voices taunting each other, the scuffle of their sneakers on pavement, and the singular sound of a basketball's bounce.

"Come on," says Saudia. "I'm gonna show you how to do this."

"Yeah," says Keshia. "You're gonna show me. Surprise me."

She bounces the ball between her legs and swings around. Saudia's got her own ammunition—Keshia's new hairdo. "Oh my God, that hair! Don't mess your hair!" she yells. Keshia tries to keep The Face, but drops the ball, laughing so hard she falls to her knees.

Saudia grabs the ball, seizing the moment in a victory dance, her voice echoing down the street. "Nope!" she laughs, "Don't want to mess that hair."

In the unforgiving world of college gymnastics, Kim Arnold and Karin Lichey were the fiercest of competitors and the closest of friends.

They met as gymnastic teammates at the University of Georgia, and were drawn to each other. They had the same fiery discipline in practice and both their childhoods were spent in the gym.

"The only thing that mattered to me was gymnastics. I don't know that I had a single friend. But Karin I feel I've known my whole life," says Kim.

They had different gymnastic strengths. But together they pushed their own limits and defined the best of the sport.

"There's a big difference between competition that is bad and the competition we have," explains Kim. "This is not about jealousy. . . . We're trying to push each other, to make each other better."

They came to Kim's final college competition—the national championship—first and second place, separated by a mere .025 of a point. It was a nail-biting finale, but in the end, Kim won.

"We were so, so close," says Karin. "When I saw the score, there was this tiny bit of disappointment. Just this tiniest of bits."

But by the time they were on the bus home, they were laughing, admitting to the odd mix of emotions that comes when disappointment is highlighted—but ultimately softened—by the grand success of a friend.

Karin doesn't know what to expect next year when Kim is gone, but knows she'll feel strange at first, unsteady.

Karin says, "We balance each other. Next year, I know I'll look around the gym and she won't be there. I don't know what I'll do."

kim arnold
and ## karin lichey

Gymnasts Karin Lichey (jumping) and Kim Arnold posing in graceful unison.

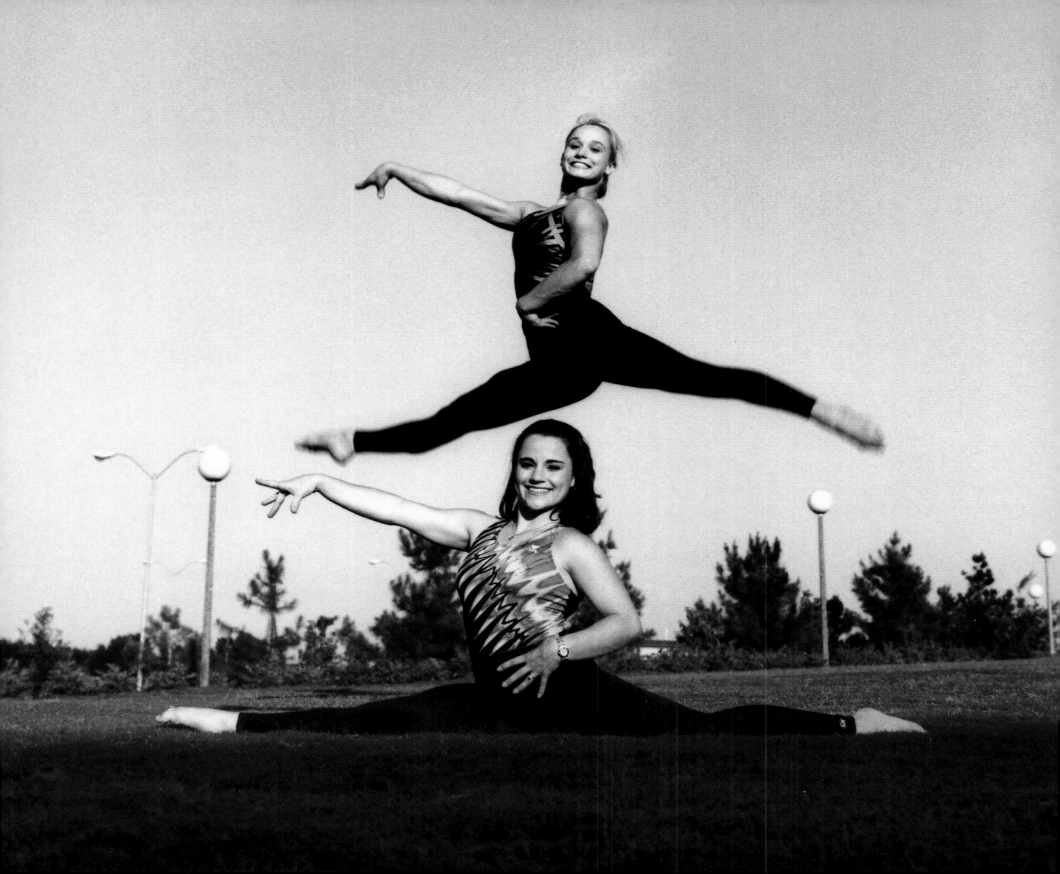

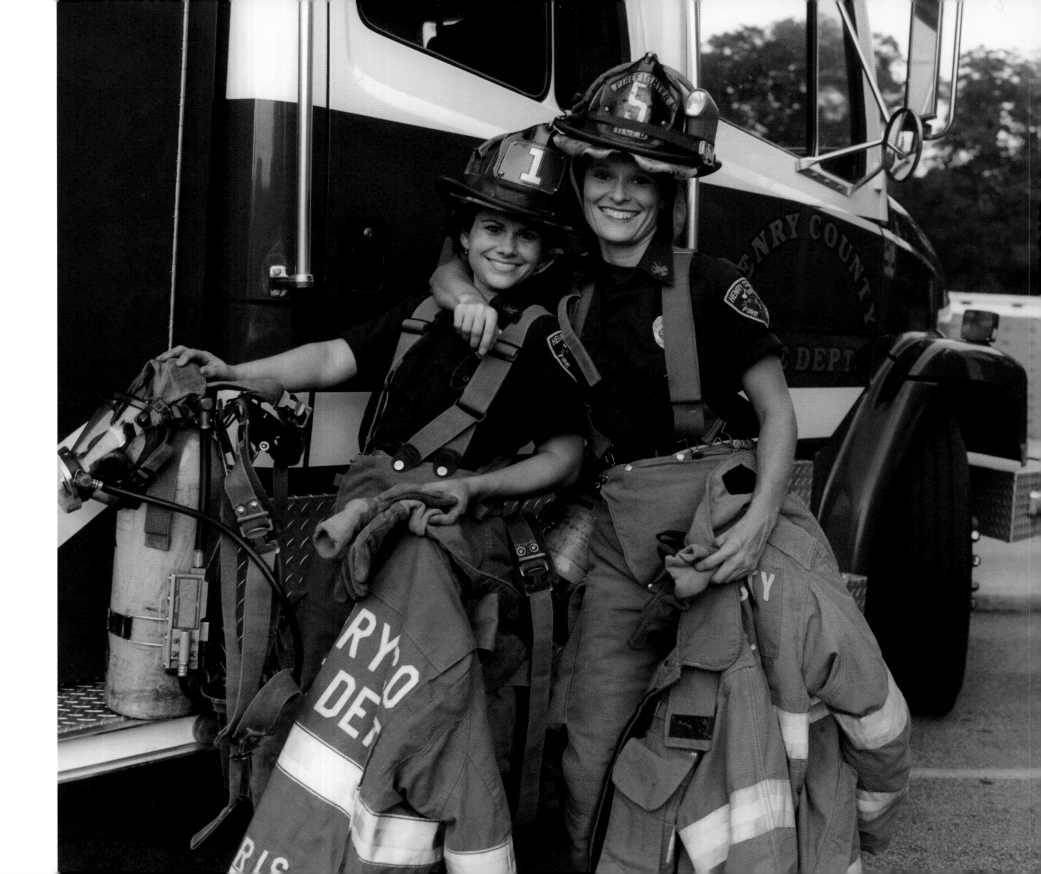

deanna a. morris
and janet l. slagle

Deanna Morris (left)
and Janet Slagle
share a break from fighting fires.

b efore they knew each other, Janet Slagle and Deanna Morris knew
they wanted to be firefighters. This was when they were both barely
twenty, out of high school and looking at the prospects for their lives.

Neither could imagine working in an office. Both longed for
adventure. They'd grown up in a part of the South where men still called
them, without irony, "little ladies." And though this was technically, if
diminishingly, true, neither woman viewed her slight stature as an obstacle
to a fulfilling future. Being a firefighter seemed the best job each of them
could ever hope to have.

They didn't imagine they'd find another woman on the force—much
less someone they could count on as a trusted friend.

"I never had many girlfriends, and I still don't," says Janet. "But even if
I did, it would be nothing like this. We don't have anyone else who sees
things the way we do."

She and Deanna are in a back room of the firehouse in Hampton,
Georgia. The rest of the crew for the night are up front, listening for calls,
watching TV, and eating take-out pizza. The two first met when Janet
came through Deanna's station for a training test. Deanna had seen other
women try out, but no one like Janet, who ran through the agility test in
an oversized uniform and a man's helmet that kept falling in her face,
hauling fifty pounds of hose back and forth, running up and down ladders,
dragging "bodies"—all with a determination that seemed unstoppable.

"It was such a relief to see another female who could do the job that way," Deanna remembers. "I was so proud when I got in. I felt like I really accomplished something, but I didn't have anyone else I could talk to who understood what that felt like."

It wasn't just devotion to their jobs that bound them. Both quickly found that they could talk about things in ways they never had—whether it was Deanna's pregnancy or how to keep their hair from being singed or how to manage the grief they'd feel after pulling a corpse from a burning car.

But more than that, each found a friend she is certain she can bet her life on.

"It's sad to say—but true—that some guys would leave you out there," says Janet. "I know she'd never do that. I know that if I go down, she'll be there—she'll pull me out."

"I feel the same way," says Deanna. "I trust her absolutely."

She is twenty-four now, a mother, married to a firefighter. Janet is thirty-one, engaged to be married. What they share is not just the love of their job, but the knowledge that few others—even in their field—possess the power that results from being underestimated and misunderstood.

"One time, we were called to rescue a guy who had fallen, a big-bellied guy. We walked in and he lifted his head, eyed us, and hooted, 'Y'all can't carry me! I want someone else,'" recalls Janet as they laugh at the memory.

"'We're what you're gettin'!' we told him. Then, on the count of three, we lifted his sorry ass onto a stretcher, just like that."

There'd been other times they were singled out because they were women. Too many to count, in fact. Times when men would tease them by flagging them down with breathless panting and mocking shouts of "Save me! Save me!" Or when they had to stand in the middle of the street with other firefighters, stopping cars to solicit money for charity—and always attracted more attention than they were comfortable with.

One day, Janet and Deanna found themselves alone on a call. This was rare enough. For starters, few women actually ride rescue together alone in a fire truck. For another, Deanna was, at the time, pregnant, and hugely so. A call came in, reporting a fire in a field. They knew, even before they got there, that this was not some little two-bit blaze. This was a mammoth conflagration, with acres of burning grass—the kind that called for a big response.

By the time they reached it, the fire was popping and exploding, gaining fast along a tract of land on the edge of Clayton County. Janet took note of the fire and wind conditions. This was land they both knew well, not far from where they'd grown up—Janet as one of eleven children, Deanna with her two brothers. As girls, they sought adventures and outdoor games, the rough-and-tumble world where they played mostly with boys.

Now, Deanna kept her eyes on the flames and hoisted herself to the top of the truck. She grabbed hold of the deck gun, a huge metal nozzle that shoots water at 1,200 gallons a minute.

Meanwhile, backup in the form of other units and the battalion chief was on the way.

fires are won or lost in split-second decisions about how much water to use, the direction of the wind, and the calculated risk to life and property. Janet and Deanna speak in shorthand, particularly when they're working—clips of sentences, economical and precise. So when Janet said, "Let's blow it!" Deanna knew she meant to turn the full force of all the water they had in their deck gun on the fire in midair. It was a risk. But one they decided to go for, in a matter of seconds.

Together, they aimed and let it loose. A massive explosion of water fell into the wind, then blew just where they wanted it to go—on the fire that raged below it.

There was a deafening roar, they recall, and then, a hush. They looked at each other, bemused, and then laughed out loud, in a sharp rush of adrenaline. They could hear their battalion chief over the radio, calling for more backup. They clicked on the radio, eyes smiling at each other, and told the chief, "Cancel backup."

"What?"

"That's a cancel," they repeated. "Fire's out."

"I'm on my way," he replied.

"Suit yourself!"

They tell the story a year later, shaping it even now through each other's eyes.

"I don't remember how many months pregnant I was then," says Deanna.

"Ugh," says Janet, pretending to hold a huge ball. "Pretty big."

They talk about other moments together that were far more dangerous than the field fire: rescuing babies from burning cars, climbing into crawl spaces and attics, small places where they can scramble fast to reach those who are trapped. They talk about times when, because of their small size and agility, Deanna and Janet were sent into burning holes of basements.

But then they return to the triumph of that field fire they vanquished. "Remember when we got back," says Deanna, "Rescue didn't believe it?"

They try to explain its significance: how they had just seconds to make a decision, how it was a fire nobody would have thought two people could handle, much less two women, and how the 750 gallons of water they had to work with could have been used up in less than a minute. They were stunned, they admit, when their timing worked so well.

"It was just a lucky guess," says Deanna, shrugging.

"But I wouldn't recommend trying it," adds Janet of their gamble to use all the power they had at once.

And then they're laughing again—at what, they don't say. Clearly, it's something that only the two of them can appreciate.

ilene rosenzweig *and* cynthia rowley

In the awful last months, when Cynthia Rowley's husband Tom was dying, she and her friend Ilene Rosenzweig had a ritual. Around eleven o'clock P.M., sometimes later, Ilene would call Cynthia, and would know, just by the sound of her voice, whether she should come over to talk.

Over time they shared many things: Paris—where they met through a mutual friend ("Tom and she and I had dinner in some little Left Bank restaurant with red-checked tablecloths—very romantic," Ilene recalls); their hopes for their futures. Cynthia's would be in clothing design, and Ilene's in the world of writing and editing. They had talked about affairs of the heart and distractions of the mind.

Sometimes Ilene would coax Cynthia out for a beer. Other times, to play basketball. Not that either of them had ever played basketball before. But suddenly, it seemed like a good idea.

The one thing they did not do, even as Tom was dying, was talk about death.

Ilene Rosenzweig (left) and Cynthia Rowley on the move in Manhattan.

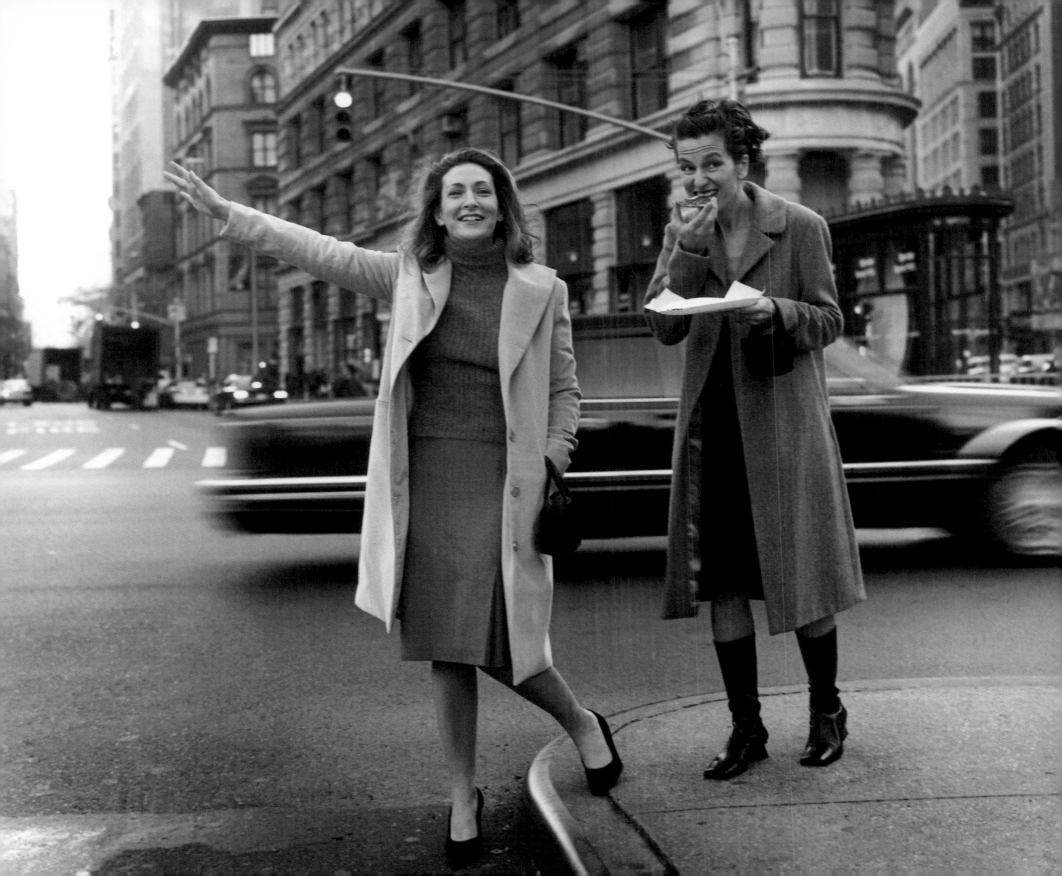

"It didn't matter what else was going on," says Ilene. "I'd come and ring the bell—call on Cynthia as if we were eight years old and I was saying, 'Can Cynthia come out and play?'"

Ilene was then living on the Upper West Side. Cynthia lived downtown, in the East Village. "We were geographically incompatible friends," is the way Ilene puts it.

"We'd dribble over to this little basketball court near the school and crawl under the fence. There were always these two little boys, and us."

"It was total release," says Cynthia. "It was like going back to being a kid, when everything was fine. All you needed was your friend and you were happy."

They are chatting in Cynthia's design studio. These days, it's located near the *New York Times,* where Ilene, who started out writing for the *Forward,* a national Jewish newspaper, and then for *Allure,* is now a style editor. Much has changed for them. Cynthia's small design studio is now a multimillion-dollar conglomerate of stores around the world, with products of all kinds—from shoes to menswear. She's received a number of the design industry's coveted awards and has appeared with all her optimistic energy on *Late Night with David Letterman.*

Though they now live just blocks apart, the pair is always catching each other on the fly. But they continue to share what they have always shared—a spirit and courage, not to mention a zaniness that would have made Lucille Ball proud.

There was the time Cynthia called Ilene on Tuesday, begging her to come to Ireland on Thursday. And that Thanksgiving in Barbados, with a couple of crazy guys who dressed for dinner

in equestrian clothes. Closer to home, they'd run off to a gym, where Cynthia was loath to set foot. Ilene would play coach.

"Even in that, there was this childlike aspect to it," Ilene remembers. "It was like when you'd play after school. 'Alright, I'm the teacher. Here's the blackboard.' I'd be pushing her through these workouts."

"Yes," notes Cynthia, "and that was the only time I went to the gym."

Then the two would hit the tanning beds (which they don't recommend) and fantasize about future getaways, possible boyfriends, seeing the Seven Wonders of the World. The light felt like the sun. Life from there looked bright.

They didn't have a plan, just an intent to shake things up and move on.

"For a time, I was saying I was Mrs. Ilene Rosenzweig because we'd go out every night," says Cynthia. "At a certain time of day, we would call each other and say, 'Okay, what's the plan?' And we would plan what we were doing that night."

"I've described the way Cynthia sees things as pathological optimism," says Ilene. "She's always looking at the bright side, and doesn't get mired down in the stuff that is so bad. That's something, especially in this confessional era, when there's such a push to be grappling with your problems and understanding your feelings."

"You know," muses Cynthia, "one of the things that's so important is that Tom was adamant that I go on and have a life—meet someone, build a future. He wanted me to be happy. He wanted to make sure I was going to be okay. And he knew

that, with Ilene, I was going to be okay. He would tell me all the time, 'Go out, go out, go out.'"

Though, she notes, he may not have had some of their adventures in mind. "I'm a real daredevil," she continues, "and usually daredevils have friends who say don't do it. But Ilene will say, 'Yeah, let's do it!' and then she'll top it. Like I'll say, 'Hey, I heard we can bungee-jump off the Brooklyn Bridge.' She'll be, like, 'Let's do it! But let's do it at midnight!' Like there's nothing we can't do. There's no limit."

They'd go out and celebrate, especially when there was no reason. Eventually, Cynthia remarried. Her professional plans grew so large, so fast, that she could barely keep pace. Ilene's options grew as well with an offer to work as an editor at the *Times*.

"I think that, for me, she is a true kindred spirit," says Ilene. "Being like you were as a kid when you didn't need to ask a million questions or sit around and overanalyze things. You're with this friend who loves you for who you are. That has defined our friendship—always looking at life with this *bon vivant* spirit, even though we've stood with each other, obviously, through some pretty dark and dramatic times."

their newest adventure is a lighthearted book, *Swell: A Girls' Guide to the Good Life,* published by Warner Books. Drawing on what they've learned in their own relationship, they note that it's not the big things in friendship that count— taking elaborate trips, buying expensive gifts. It's paying

attention to details, the little things. Like playing basketball.

Despite their literary collaboration, getting Cynthia and Ilene in one place for long is not easy. Their lives are fast-paced and their friendships give it all—even the bad times—powerful momentum. Talking on their cell phones, juggling schedules, they're always on their way somewhere. Still, they keep their friendship intact.

On this day, there's barely time to eat, or even to begin to catch up on the day's events. They talk as they race from one obligation to the next—while flagging down a taxi, even as they climb in the back. But before it leaves, Cynthia unrolls her window, seizing that last second to offer a final summation of her pal: "Ilene is someone who makes the bad times good, and the good times dangerous."

helen colijn
and ruth russell roberts

uth had arrived at the camp with a beautiful slender figure, but was now so thin her bones stuck out. We had exhausted discussions on such high-society events as playing cricket. Now we played the game of daydreaming.

One morning I noticed that the bamboo pole between us that we use to carry wood, made the same creaking noise as my saddle had made when I rode horseback with my family in Holland. The dismal barracks, the dry-season dust swirling up in the compound, were gone. I was cantering along a Dutch beach. . . . The wind blew across my face. I saw the sand dunes . . . the dark green sea . . .

"What are you thinking about?" Ruth asked me.

Soon it became a habit for the two of us to "go daydreaming," sharing lovely memories of the past as we hauled wood to the prison camp kitchen.

By the time Helen Colijn would write these memories, she had long since survived four years in a Japanese prison camp in Sumatra during World War II. She was a student from Holland, visiting her parents who were stationed in the Dutch East Indies with an oil company. The Japanese invaded the nearby island of Java in early March 1942, and Helen, then twenty, an age when so many relationships are defined, would spend those critical years just trying to survive.

For years she buried those memories. She moved to the United States, married and divorced, raised a daughter, worked as a translator at Stanford, a tutor, and an editor for *Sunset* magazine. Only in writing her memoirs

85

would she discover that two powerful and miraculous things came from the war. One was her memory of a chorus, which the prisoners formed. This would give her memoir its name: *Song of Survival*. The other was finding a friend like Ruth Russell Roberts, realizing that even in war, the simplest of acts, like talking to someone who understands you, can do much to keep the human spirit alive. Though she and Ruth didn't think of it that way at the time.

"There is a tendency to imagine life in the camps in almost a romantic way—intense bereavement, people helping each other," says Helen. "But we were so deadened."

She pauses, considering that last word. Frail now, her voice is thin, a mere scrim of sound. Words sometimes come to her in Dutch. "Dull," she decides. "Yes, that's it. We were so dulled."

Although both were loners by nature, they shared the job of hauling wood, and so they talked, because that was all they had. Helen spoke of Holland, where she grew up and was boarding with a Dutch family until she came to visit her parents in the Dutch colony. Ruth taught Helen proper English and talked of travels with her fiancé, an officer in the British Army. She was taken captive while in Singapore.

Ruth and Helen were twenty-one in this first year of captivity, unaware that they would spend more than four years dragging their bodies and what hope they could muster from one isolated camp to another, each worse than the last. They were prisoners of a war that shook the world, but were so far on its edges that, even once the Allies won, it would be weeks before they'd be discovered in this remote spot. And so

Ruth and Helen sought escape through their daydreams.

"Any friendships I made in the prison camp were circumstantial, a matter of luck," she continues. "Why did I see a lot of Ruth? Because we volunteered for the same job."

They talked and dreamed, but they watched other women die. There were Australian Army nurses, a group of Catholic nuns, and British colonials living overseas suddenly forced to try and keep themselves and their children alive.

"The thing I remember from all those years is the tropical heat—very damp, very humid, very oppressive heat, and torrential rains. The rains came from nowhere and would stop and then start again, and just pour over you. . . . We moved from camp to camp, and so often the friends you had, whatever you had with one person, you'd be moved and lose track of each other. That's what happened with Ruth."

When the war ended, it was as though the memory of the time itself became interred, buried with all the women whom Helen had seen die.

"We came to California, because we had lived here before and had friends here," she explains. "But friends didn't have an inkling, an idea, of what we had gone through.

"On the other hand, you did not have to talk about those camps. Let's forget. Let's forge ahead. Our feeling was we needed to get on with life."

Which she did. Then one day, in 1980, Helen's sister, Antoinette, was rummaging in the attic of her home in

Washington, D.C., and found a sixty-eight-page booklet of vocal orchestra scores she had put together just after the war to save the music some of the prisoners had sung. There, fading but still legible, were the notes that one prisoner, Margaret Dryburgh, had made nearly forty years earlier. "Miss Dryburgh" wrote music—scores an orchestra would play—from memory and taught the other prisoners to perform it with the only instruments they had—their voices.

Antoinette donated the music to Stanford, but the discovery flooded Helen with memories. She began to write of her capture, the camps, the music, and Ruth. The resulting nonfiction memoir was published as *Song of Survival* in 1995. By then the music had been performed by the Peninsula Women's Chorus of Palo Alto in a concert which Helen introduced called "Music in a Prison Camp." Then came a television documentary, also called *Song of Survival*. There were other concerts—one united nine of the camp's survivors. Australian director Bruce Beresford turned the story into a film, *Paradise Road*, starring Glenn Close.

For Helen, what had been so long dead inside her became brilliantly alive, sparking ideas and possibilities. She stands now, even when she's alone, having touched off ripples of concentric circles that link her to lives that are past and some she's only beginning to know.

"Isn't it odd?" she says. "All of the people you meet, you think, *If I hadn't stepped into that store, or if I hadn't read that book. If I hadn't reached out* . . . So many friendships came from that experience, directly or indirectly."

One day, in their last year of captivity, Helen heard that Ruth had died. Helen ran to the makeshift morgue, and found her friend's body waiting to be buried.

"It was a shock, but probably more of a shock afterward. A lot of the trauma is not at the time, it's thinking about it later, or looking at it from present day to the past.

"There were so many deaths that you just sort of shrugged your shoulders and thought, well, she's not there anymore. It happened to us all the time. But I realize now it must have been a shock. Ruth was the first person I saw dead."

Helen also knew Ruth in a way few others in the camp did. She'd learned a bit about her friend's earlier life, and she knew that Ruth had a baby girl. She had made only brief references to her past, telling Helen only that she had done what so many other women had done who feared for a new baby's life—she sent her away to live with relatives in England.

The baby, Lynette, was six months old at the time. It would be years before Helen would have the courage to try and find her. In the process of researching her book, she discovered that Lynette was a married mother herself, living nearby.

Helen went to her house, has talked with her since, and holds onto a rare photo of Lynette on her mother's lap. It is a tangible reminder that from even the most devastating times, the human spirit can survive.

"I thought she would like to know that I saw her mother," Helen says, "that I talked to her . . . that she was my friend."

kathleen curry
patricia hunt dirlam
holly guild hudson
and
cindy mathews

One fall day in 1989, four women found themselves in the basement of an old building in Boston. The place itself had long been a refuge for women who needed schooling or a job. But these women were not coming for either. They had come to take a class in needlepoint.

All were in their forties, working in powerful jobs. They'd come to the class, they thought, to try something different, a distraction from daily demands. But inside them also ran a longing for something they could not name. For each of them, life in the nineties would present major change. Cindy Mathews was about to lose a job with a prestigious publishing company. Patti Hunt Dirlam would leave Harvard, where she'd worked for twelve years. Holly Guild Hudson would end her marriage. Kathy Curry, a high-profile attorney, would be diagnosed with cancer.

They didn't know any of this when they first met that day. Just as they didn't have a clue that they would become such profoundly close friends.

"I expected a bunch of elderly women with blue hair," Cindy Mathews remembers.

What they would find there would allow them to weave a net of friendship so strong, it would bear the weight of their personal struggles.

"Without these three people," Kathy Curry says simply, "I don't know what would have happened."

Ten years later, the four friends sit around a polished table in a store called Wellesley Needlepoint Collections. The store came about after Cindy walked into work one day and learned she no longer had a job.

Patricia Hunt Dirlam, Cindy Mathews, Kathleen Curry, and Holly Guild Hudson (left to right) toast to their friendship and to each other.

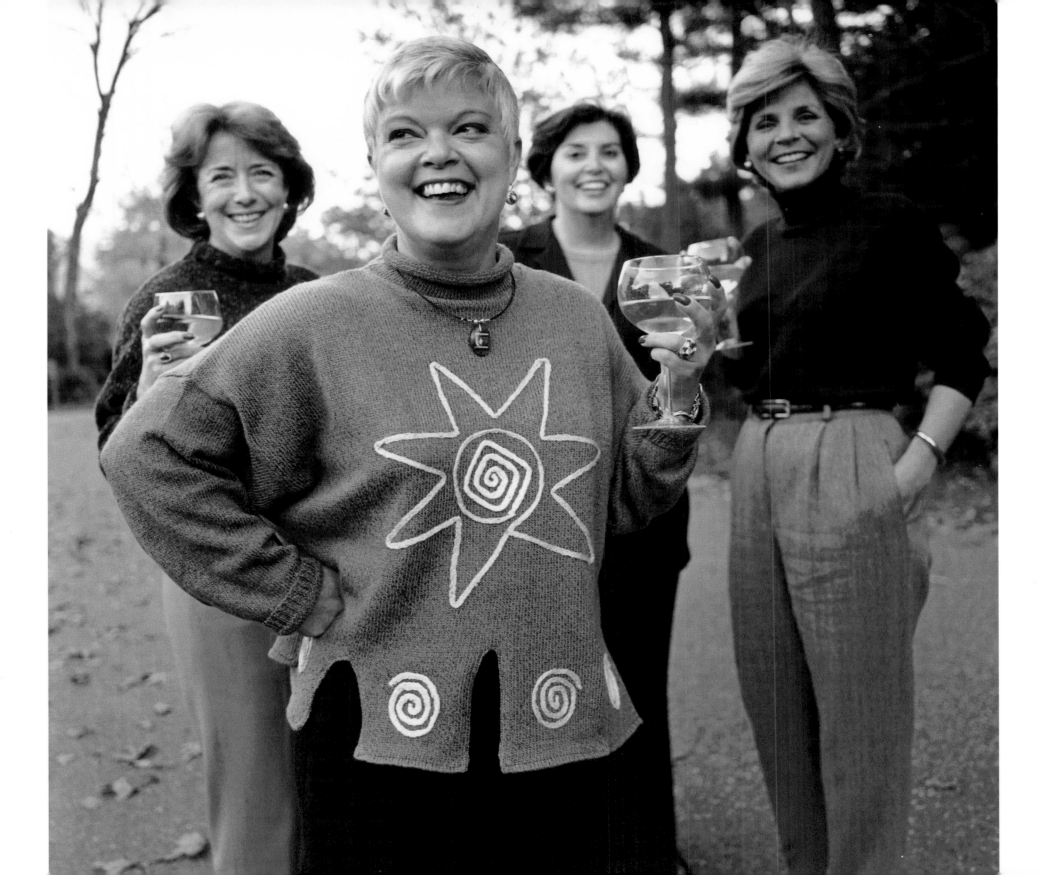

"I had this great job, and I loved it, with this wonderful office overlooking the Boston Commons, five minutes to Filene's Basement," she says. Her friends murmur in agreement.

"And then, kaboom! Out of a job. What was I to do?"

Cindy ran through a litany of ideas, including graduate school and consulting. But what she wanted, she knew, was to open this shop.

"I was kind of embarrassed to tell people what I was thinking," she says. "But these guys were incredible. They didn't say, maybe you should be doing consulting, or what are you going to do with all your business suits?"

"We said, 'Great idea!'" Kathy recalls.

"I think we talked about names immediately," says Patti.

"Location," someone adds.

"You gotta have a business plan," another says.

"'When do you want to open?'" Holly remembers. "That's what we started from."

Once Cindy's decision had been made, the others pitched in to help. They took turns volunteering to get it ready, and then on weekends, to work in the store, piling threads into bins—whatever it took to get the shop off the ground.

Together, they had resources any big corporation would envy: a career coach, an interior architecture designer, and their own personal attorney.

Often they'd help each other at critical junctures in their lives. Patti finished two years of college and then worked at Harvard as a staff assistant. One day, she found herself listening to a doctoral candidate who seemed to know very little about basic common courtesy.

"It was one of those moments," she says. "I remember I thought, *If this guy can go to Harvard Business School, I can finish my bachelor's degree.*"

Within five years, she'd completed college, was attending graduate school at night, and started a consulting business, all while working full-time. Eventually, she became the university's associate director of employment and training. Though Patti doesn't have children of her own, she wanted to divide time between her now successful consulting practice and her nieces, nephews, and numerous godchildren. Later, her friends helped her decide to pursue her career part-time.

"I may not have children," Patti explains, "but I don't have to be childless. I try to practice so much of what our friendship represents. Everyone can help someone at some level. You need to find support to explore the world, and find out who you need to be rather than who the world tells you to be. It's the relationships we build in our journey through the world that help us get to our destinations—like Cindy's shop. We never become successes by ourselves."

Holly nods in agreement.

"I'm probably the one in the group who most came from the school of hard knocks," she says. "I'm the one who, almost by necessity, had to become successful."

She's been a single mother of two and entered the design field with a nontraditional education. She became an award-

winning interior designer, the director of a thriving business, and then found herself divorced again.

"I'm the Zsa Zsa of the group," she says, laughing.

It is through these friends, she says, that she found the strength to change and thrive.

"I learned that the things I thought were shortcomings in my personality, embarrassing things in my life, were just lessons to be learned," she says. "Sometimes I've chosen a left road when I should have chosen a right. But these friends helped get me where I needed to be."

"And Holly," notes Cindy, " is the trusting one."

"You need to say that you're a really great mom," Patti tells her. "You raised two boys, and a stepdaughter, and you have a wonderful relationship with them."

"Yes," says Holly. "I have one twenty-six, a twenty-seven year old, and another twenty-nine, and I'm going to be a grandmother and they are fabulous children. But there was a point where I would have traded any one of my children for a new pair of shoes. It was so hard."

"Whenever one of us has adversity in our lives, the others make us see the humor in it," says Patti. "There's a lot of laughter. We give strength when it's needed, but we don't let ourselves get down because of the hard times."

Holly agrees: "I think, too, that we're all born with talent, but sometimes you don't recognize it until late in life. Our talent is usually something that comes easy to us, and so sometimes we have a hard time recognizing it as talent, but it's what distinguishes us."

Holly points to Kathy, a high-profile litigation attorney. "She's my lawyer. She knows secrets about me . . ."

"I try to keep them out of trouble—particularly this one," Kathy says with a laugh, nodding toward Holly.

"There are four of us, but only three are loudmouths," Cindy explains. "Kathy's the listener, the thinker, strong and too modest. When she talks, we listen."

"I had a wonderful grandfather, Pa McGuire," says Patti. "I remember someone saying to him, 'Pa, how come you don't talk?' And he said, 'Someone has to listen.' He had great wisdom and so does Kathy."

When the group learned Kathy had been diagnosed with cancer, they rallied around her, supporting her through the effects of the disease.

"I think maybe one talent we have in common is a talent for friendship," says Kathy.

Outside the sky is darkening. It is near 5:30, the time when they used to come to class. Now, as they relax around the store's table, all around them are reflections of their friendship. It is the place to get the basic needlepoint necessities—plus intricate, deeply beautiful patterns that are often touched with outrageousness and whimsy.

"This is a friendship that nurtures me as a woman," Cindy concludes. "I don't have to pretend to be anyone but who I am."

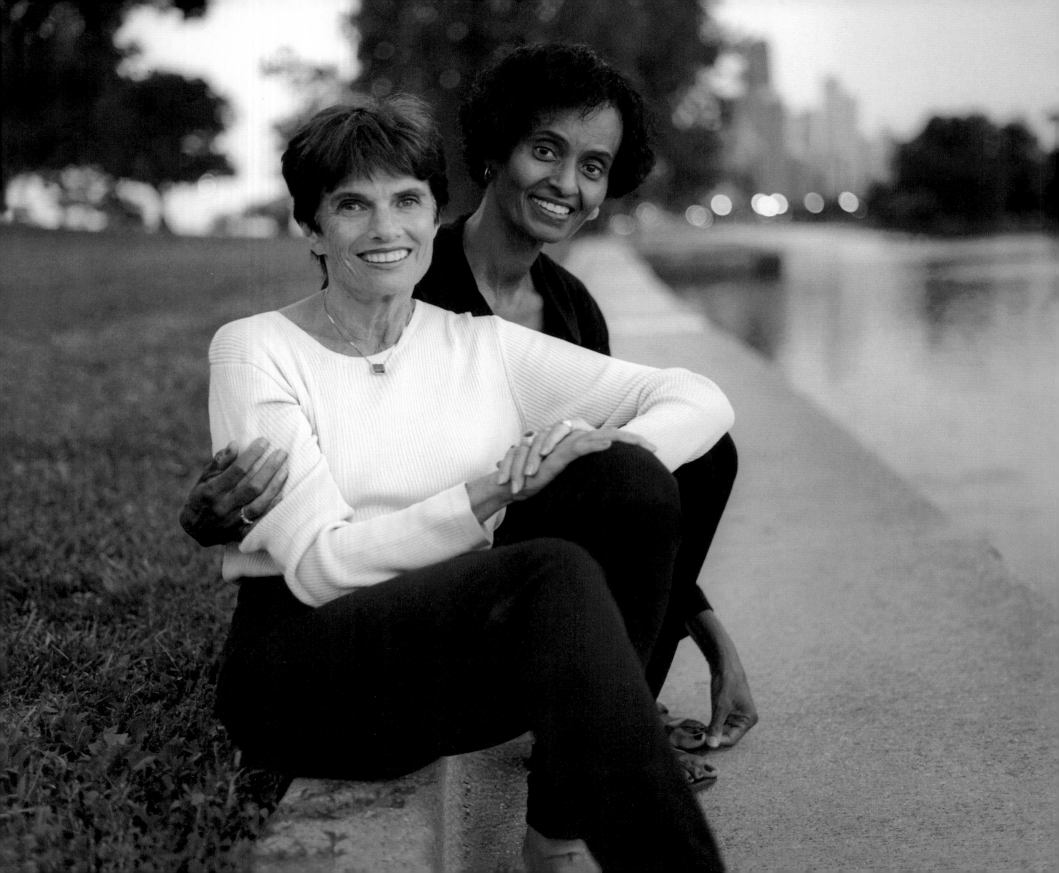

jo lief
and wini scott

Oone day, in 1971, Wini Scott and Jo Lief spied each other across a conference table at Children's Memorial Hospital in Chicago. Wini was the new group coordinator there, a tall, strikingly beautiful black woman, and Jo was a social worker who was to work for her. But looking at Jo for the first time, Wini knew what she saw—a handsome, well-dressed white woman, probably from the city's posh northern suburbs—someone likely to understand little about Wini or her life.

"I remember, you were sort of scrunched up in your chair, and the reason I remember so well is because I thought, *This woman will never see me.* Isn't that so funny?" Wini says.

Wini was partly right. Jo was from the city's wealthy North Shore. But at that moment, she was flat broke: a single mother, trying to provide for herself and her baby daughter. For all that divided these two women—their backgrounds, their race, their assumptions about life—they would be bound by circumstance and a heartache that ran deep within both of them. Single mothers, struggling to build careers, they turned to each other as refuge and resource.

"I've had girlfriends before," Wini says, "but I don't think I've ever had a friend like her." She turns toward Jo, seated next to her in an elegant Chicago restaurant, unsure Jo heard her. "I mean to say that you are unusual and unique. You are the friendship that means so much to me."

Jo Lief (left) and Wini Scott enjoy a Chicago afternoon together.

93

Jo exaggerates a look behind her, as if she thinks, for a moment, that Wini is talking to the waitress. Then she laughs, and squeezes Wini's hand.

They've been friends for nearly thirty years now. They've seen each other through devastating catastrophe (Wini's daughter's brain surgery, the death of Jo's stepson) and unexpected joy (Jo's remarriage), as well as through consciousness-raising groups, spa weekends, and the redecoration of each other's houses.

Their friendship spanned a time in the country in general, and in Chicago in particular, when limits set by race, sex, and roots were changing explosively.

"We were both divorced, both single parents, and I can't emphasize enough how important that was," recalls Jo. "The friends I had known really had no understanding of what my life was like. I was poor, and terrified. I was definitely not a princess, though I was raised to be one."

"That's so funny," says Wini, recalling the first time they met. "Because I thought you *were* a princess."

"And here I thought you were so beautiful," counters Jo. "I thought, I have to meet this person. And I surprised you because I saw you?"

"You surprised me because you wanted to be friends with me," says Wini.

Eventually, Jo took over as group practice coordinator, for Wini resigned from Children's Memorial Hospital to pursue a Ph.D. They began a routine of supporting each other—at first, with simple things. Wini gave Jo advice about the job.

Jo encouraged Wini in her graduate studies, leaving her cards and inspirational notes. When they found the time, they went out for lunch, and when they were dieting, they shopped or looked for small adventures.

Soon after they met, Wini's daughter, Stephanie, suffered a serious head trauma. As Stephanie underwent surgery, Jo rushed to the hospital and stayed with Wini through the awful, uncertain nights.

Stephanie made a full recovery. She is now thirty-three; Jo's daughter is thirty-six. At the time of her accident, Wini recalls, the horror was made bearable because Jo was there.

"You supported me so much through the whole thing," Wini says. "You always saw Stephanie as a special child. She is special. She's smart, and with it . . ."

"She's the best," says Jo, nearly overcome with emotion.

"She's one of the best things I ever did—her and my other daughter Lynn, don't you think?

"Absolutely."

When they were certain Wini's daughter would survive, Jo dragged Wini out of the hospital to her house, where she and other friends gave her enough to eat and drink that they were certain she would sleep. As they survived through more and more struggles, the differences between them seemed increasingly inconsequential.

"I want to say something about the race difference," Wini says. "Because that's very important to me. I have had other

white friends, and there's something that happens between women—at least something I see when there's a racial difference. There's this tendency some women have of expecting me to be deferential to them.

"Part of that is my basic personality," she continues. "I have a kind of deferential part to my character anyway. I can't explain it well, but it has to do with fairness, this sense you have that the person is sort of looking down on you. . . ."

For many years, Wini and Jo pursued their friendship assuming that race was not an issue. They were no longer working at the same place, no longer tied by circumstance, but instead made sure to spend time with each other. But about eight years ago, Jo entered a Gestalt training program where she was accused, by a group of black colleagues, of racist behavior toward them and in her work.

She was stunned. "They hated me!" she recalls. "Because I was white, and because I was strong and outspoken. I lost my voice—literally. I felt for the first time like I really knew some of what Wini goes through. For the first time, she and I sat down and had a good talk about it."

It was their first conversation about race and the first time Jo saw it from her new perspective, having experienced what she described as reverse discrimination.

"We fought," Wini remembers. "We did."

"You have to understand," Wini continues, "that I was raised in an era before Black Power, before the "black is beautiful"

movement. There was my mother who told me I would succeed, and that was it. She didn't know how, but she was sure I was going to do it. So I didn't share the same racial awareness of people coming along even ten years later. My black friends who are younger—they're much more assertive and self-aware.

"I think what we came to realize is that our friendship is about so much more than race," she continues. "I tell you that all the time," she says to Jo. "You set an example for me."

"We're so similar," says Jo, "but we have the room for difference. That's what personal friendships can do—show you things close up that you wouldn't have seen. For instance, because I'm Jewish and Wini isn't, she's my Christmas person. I get to celebrate with her. It sounds like a small thing, but it's not."

Wini nods. "The way people come to really, really understand things is not from being told. It's from living them, close up, through a friend."

If they survived their youth by relying on each other, they plan to celebrate their age the same way.

"Isn't it interesting," Jo says teasingly then, "we're getting older? We have this thing we call CRS—Can't Remember Shit. Sometimes we forget things. But we forgive each other."

"And we have this picture of growing old together. We've had that for a long time."

"Yes," Jo says with a mischievous laugh. "We're going to sit in rocking chairs, and use our vibrators. . . ."

sylvia elizondo
and macarena hernández

though they chose different paths and have gone in different directions, Sylvia Elizondo and Macarena Hernández grew up knowing the same past.

Their mothers were raised as cousins in a small Mexican ranch town called La Ceja, then settled in La Joya, in a South Texas valley where Mexico and the United States are separated by a narrow gap.

Sylvia and Macarena would grow up almost like sisters. They would have other friends, but no one who knew life from before it started—the places and people of their mothers' past.

"It's kind of like the difference between a biological mom and a stepmom," Macarena says. "You may have a great stepmom, but your real mom knows everything about you. No matter how close you are with your stepmom, she doesn't have the history, the details."

They went everywhere together—to school, to church, sneaking out the window late at night just to walk the few blocks between their homes, secretly under the late-night stars. Their parents were farmworkers and in

Macarena Hernández (left) and Sylvia Elizondo reunited at Macarena's grandfather's ranch in La Ceja, Mexico.

the summer they traveled the same route through Texas or California to pick cotton or grapes—and so Sylvia and Macarena saw the same horizons and slept in the same make-shift houses, often on flimsy mats.

But even then they were different in temperament. Macarena was filled with fire and passion. She saw a life that went on beyond the valley, where most people they knew stayed and married and raised their own children. Sylvia never thought of herself as someone who would leave.

"Macarena was always the risk-taker. I was the introvert, so stubborn," Sylvia laughs now. "She'd convince me, 'Come on, come on, we're never going to do it otherwise.' And this was just to walk around the block. Outside, she'd be like, 'Look, look.' Imagine if someone saw us! She talked me into so many things."

then, at seventeen, Macarena won a scholarship to college and decided to go to Baylor University in Waco. She tried to talk Sylvia into coming with her, but Sylvia couldn't imagine leaving.

The day Macarena drove to school they both wept. She was leaving her history and culture, going to a school where many students were white. Sylvia figured the two friends were about to go their separate ways and knew they would both change. But from nearly the moment Macarena arrived at Waco, she waged a campaign to get her friend there, too.

"Mac never gave up," Sylvia remembers. "Every time she came home or called she was always going on about something—politics or feminism—and she'd get me thinking about everything. She'd be like, 'Sylvia, you need to leave the valley. How are you going to know who you should become?'"

"Oh my God," Macarena laughs, remembering. "I was like 'Sylvia, you're falling apart.' I'm sure part of it was that I'd come home and here she'd have this life I knew nothing about. I had completely changed and it was like, 'What's happening to us?'"

Away from home, Macarena dug deeper into her culture, sought out things that had always surrounded her—Spanish music, books, her history, her parents' past. Sylvia would watch, puzzled, as Macarena, visiting home, switched Sylvia's radio station to a Spanish station, sought out Spanish clubs, longed to go to Mexico in search of a new shirt.

"It was as though I was lost in my own culture, like I had to get away to value it," Sylvia remembers. "I was surrounded by so much of it that I couldn't even see it. Mac was so much stronger, wanting to do so much, to change the way people perceived things, and it was as if she transmitted that strength and made me feel like I could be somebody."

After two years, Macarena finally won Sylvia and her parents over and Sylvia moved to Waco. She took classes at a local college and began to discover what she wanted and who she was.

From there their paths parted: Macarena went to graduate school to study documentary filmmaking, then to internships as a reporter for the *Philadelphia Inquirer* and the *New York Times*.

Sylvia discovered her love for the Spanish language and culture and transferred to Texas Tech in Lubbock, hoping to eventually teach Spanish to high school kids.

But where Sylvia had turned to Macarena as a way out, Macarena turned to Sylvia—calling her, e-mailing her, making plans to reunite—because for her, Sylvia was home.

"Sometimes," Macarena says, "I'll pick up the phone, maybe at two, three in the morning. I call Sylvia. . . . We'll talk about nothing, about who's married, who's divorced, who's eloped."

Now at twenty-four, uncertain about the next step in their lives, they hunger for a taste of home. They've hooked up on this day, after months apart, to see their families, to see each other, to revisit their past. They decide to spend a day together in La Ceja at the ranch in Mexico where both their mothers grew up and where Macarena's grandfather still lives.

•

Inside the ranch, it is dark. They light up the stone oven and sweep the floor and grow sweaty from the air, which is heavy and hot. They cook *carne asada* and fresh salsa and a big pot of rice. They drink grape and orange Joya soda from bottles and rock in old woven chairs and share stories they've heard that stretch back to Pancho Villa's days.

Up the hill they see the old school where their mothers studied. Macarena and Sylvia walk toward it in awe. They run their fingers along the arched doorway, across the peeling, worn walls, along benches where their grandparents sat to watch the schoolchildren dance.

"Can you even remember when we met?" Macarena asks. "Doesn't it seem like we've just always known each other?"

"Hmm," Sylvia says. "The last time I was here, we were fifteen . . ."

"I remember. Your grandfather died, and you were so scared that you'd lose your tie to the farm."

It's as though they're retracing their route—past to present, reconsidering where they have been so they know which way to turn next.

"You talked me into so many things," Sylvia recalls.

There were Sundays in church, sneaking out together at night, remembering their first kisses. There was the time Macarena was working for the chamber of commerce, for a man who had an earful of Macarena's views on feminism and the contributions of Latin-American women. When the Latina singer Selena died, the man turned to Macarena, asking her to speak to the singer's fans in Waco.

That is a moment neither one of them will forget.

"You were writing the speech while I was driving, remember?"

"I was like, what do I say? I didn't know what to say. I mean, I liked Selena's music, but I wanted to talk about women—Mexican-American women who were inspirational, remember?"

"And then nobody was listening. You were talking, and . . ."

". . . everybody just wanted to sing and dance," recalls Macarena with a laugh. "Oh my God, they did not want to hear some inspirational speech! It was so embarrassing. God, don't remind me."

The episode feels even more improbable to them now, standing inside a place that generations ago was a school. Now it is empty, cavernous, and dark.

"Okay," Sylvia says in a mock-accusatory tone. "How about the time—remember—you were afraid I was going straight to hell. You made me repent."

Of course Macarena remembers. Sylvia's family didn't go regularly to church, but Macarena did—and convinced Sylvia to go with her. But she throws her head back and laughs, waving at flies as if to keep the memory at bay. "No! This I do not remember!"

"Yes, yes, you do," Sylvia persists. "I remember. It is one of my most vivid memories. We are in church, in the second pew right near the front . . ."

Macarena tries changing the subject. "You know what I was thinking . . ."

Sylvia ignores her. "We were sitting near the very front. And you said, 'Please Sylvia, you better repent. I don't want you to go to hell.'"

"Oh my God."

"I was like, 'I repent! I repent!'" Sylvia throws up her hands as if feigning and pleading surrender. "'I don't want to die and go to hell.'"

"I was so young," Macarena says.

They're falling over one another now, laughing.

"Ah, *m'ija!*" Sylvia laughs, then sighs. "*Was* is the word."

Later, they will say how the world felt so far away. They will talk of their daily struggles to find a good and right future without drifting too far from the past. Theirs is an inherited friendship—one that began years before they were born, one that will grow with moments and memories beyond anything their mothers know.

But for now, there is comfort in the stillness. The air smells of mesquite, and in the distance they hear chickens and sheep, sounds from Macarena's grandfather's ranch. Somewhere a dog barks, and the sound comes loudly, urgently, then fades.

"We should go," Sylvia says.

They head toward the ranch the short way, but come to a barbed-wire fence. Macarena slides underneath, slowly so her shirt doesn't catch. Sylvia goes next. "Be careful, *m'ija*," Macarena says, gently pressing Sylvia's back.

Then they run downhill, leaving behind the deep echo of their laughter, the ranch, and the school with its old walls that seem, from a distance, like their friendship—not as it once was, but as something that made them who they are and who they might become.

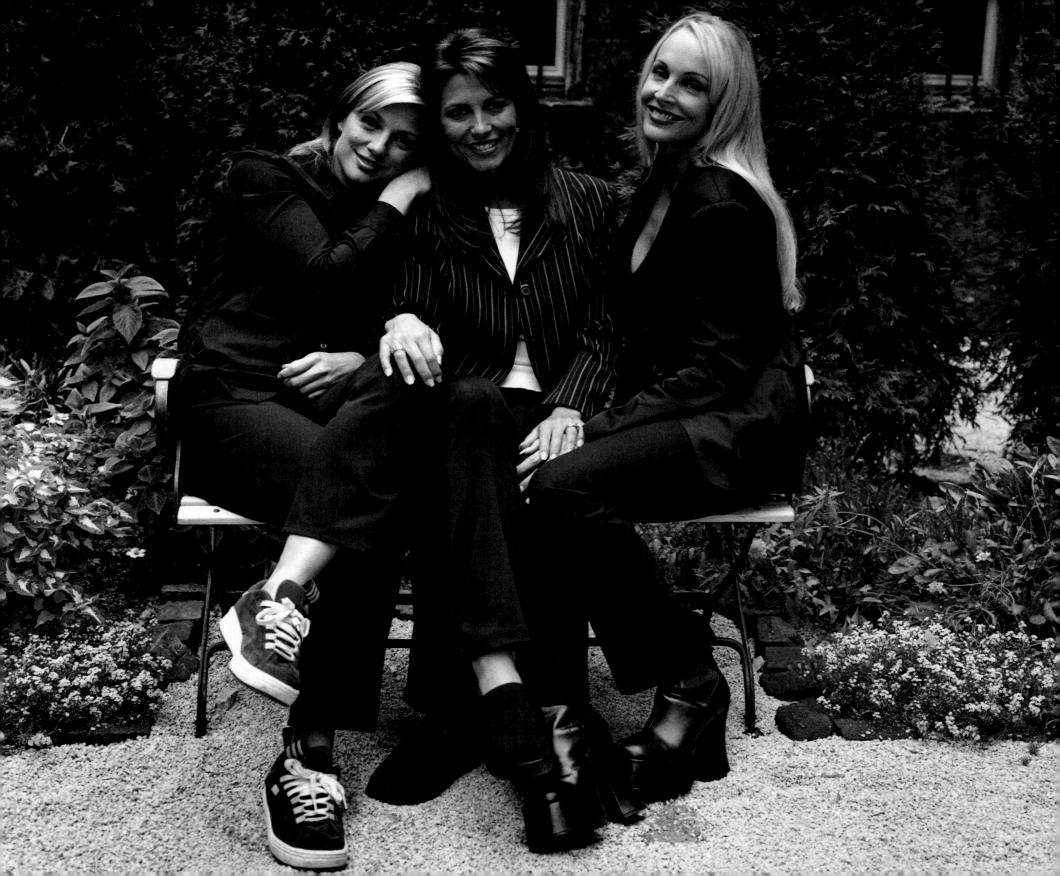

rebecca besser
debra mcmichael
and eleanor mondale

"There's a certain girl-thing you don't have with spouses. There's something about girls and friendships that is just this amazing mystery," declares Rebecca Besser.

"Girlfriends can't divorce you," says Eleanor Mondale.

This is the topic of the moment because Eleanor, Rebecca, and Debra McMichael are having lunch. It is the topic of the moment because among the things that these women know, the constant factor is that men come and go. Awful experiences come and go. But your girlfriends are always there.

These women have been best buddies for fifteen years. Among them, they know many things. Eleanor knows a lot about being the daughter of a vice president, and being in the public eye—currently as an entertainment correspondent for *CBS This Morning*. Debra knows a great deal about wrestling since she's been the unofficial princess of the ring for various professional leagues. (She also knows about pink Christmas trees, and about dressing her dozen dogs as Santas, but that's another story.) Rebecca, a former television producer, knows about motherhood, for she has four kids.

Eleanor, they all agree, tends to be more high-maintenance than her friends. Debra has issues—a recent divorce, family disputes. Rebecca has issues—she's a wife, mother, friend to numerous organizations, especially the Special Olympics. But Eleanor has ISSUES.

"It's embarrassing," Eleanor concedes. "I can have a conversation with Rebecca for twenty minutes about the most disastrous thing and she's like, 'Oh, thank you, I feel so much better. Now let's talk about you.' She's done with it. And I feel so bad because I've just called her every day for a week."

"Every half hour!" Rebecca reminds her. "There are some days when we're on the phone every fifteen minutes. At three in the morning, my husband picks up the phone and says, 'What now, Eleanor?'"

In 1984, Eleanor's father, Walter Mondale, lost his bid for the presidency. Eleanor was hurt to discover the truth behind the old saying that a winning candidate has all the friends in the world, while a former candidate has friends who are always busy. As for the daughter of a former candidate, she often had doors opened for her simply because of her name. Suddenly, Eleanor found that people who had returned her phone calls a week earlier were not there.

"People stopped calling me back. It was horrible," she

recalls. "I was twenty-four, but it was still shocking."

Eleanor set out for Los Angeles, to become an actress, then returned to her native Midwest—to Chicago, where she was hired to do morning drive radio. There, she met Chicago Bears offensive tackle Keith Van Horn. Debra and Rebecca were dating two of his teammates, and the three women crossed paths in a wives' waiting room.

One day, in the bathroom, Eleanor ran into Debra, who was crying over a fight she'd had with her husband. (Ironically, the couple was to appear on *Oprah* the next day as part of a show about happy couples).

"I was ranting and raving, telling Eleanor never to get married, that marriage is terrible," she recalls.

At that moment, they became friends forever.

"Debra has her own, shall we say, style," says Eleanor, referring to her friend's big hair, big nails, and flashy clothes.

"I'm gaudy, darling!" is how Debra puts it.

Soon Rebecca, who was the producer of Eleanor's television show, joined them. Every Tuesday, the threesome would disappear to their "girls' lunch," where they'd write notes about their lives (sure to become a fabulous novel, they would joke), and talk and laugh until dinner time. They bought identical leather jackets, and gave each other nicknames: Trouble for Eleanor, Babydoll for Debra, and Princess for Rebecca, who dresses in Chanel.

"It was such a nice bonding time," Rebecca remembers. "We got to be girls away from the whole football thing. Even though our personalities were so different, we would just laugh and

laugh and enjoy being goofy, and it had nothing to do with the men we were dating, or Eleanor's father. It was just us."

Their friendship only grew stronger.

Once, Eleanor and Rebecca went to Minneapolis, Eleanor's hometown, for a Super Bowl. At a post-game party, Rebecca spied Jason Priestley of *Beverly Hills 90210* whom her young daughter idolized. So Eleanor approached him, got his autograph, thanked him, and gave it to Rebecca.

The next day, the gossip page of the local paper featured a lurid tale of how Eleanor had supposedly grabbed Priestley's crotch, and how he'd slapped her.

"I was there!" Rebecca cries, her face still flushed at the memory. "I was there, and this didn't happen. They totally lied. We went back to Chicago and Eleanor was crying and her parents were so upset. It was awful. And here she was only trying to get an autograph for my daughter! I kept thinking, They love to hate her because she's so smart, and so beautiful."

"It's not an isolated incident," Eleanor says.

But it helps explain why her friendship with Debra and Rebecca means so much.

"If I didn't have them, I'd go nuts," she says. "You start to second-guess yourself, like, what did I do?"

"Even if I just have a little fight with my husband, I'll call up Eleanor or Debra and say, 'Can you believe him?'" says Rebecca. "It just means everything to have that person on the other end of the line saying, 'You know what? You're right. You're great.'

"I'm telling you," she says. "That's support you can only get from your girlfriends."

When they get together now, they step out as a threesome devoted to each other, dancing and laughing until dawn, caring little about how they're perceived.

"Sometimes, you have friends who are there only in the bad times or the good times. We've been through each other's ups and downs. And though we can't always be together, the closeness is there," says Debra. "We all know we're never alone."

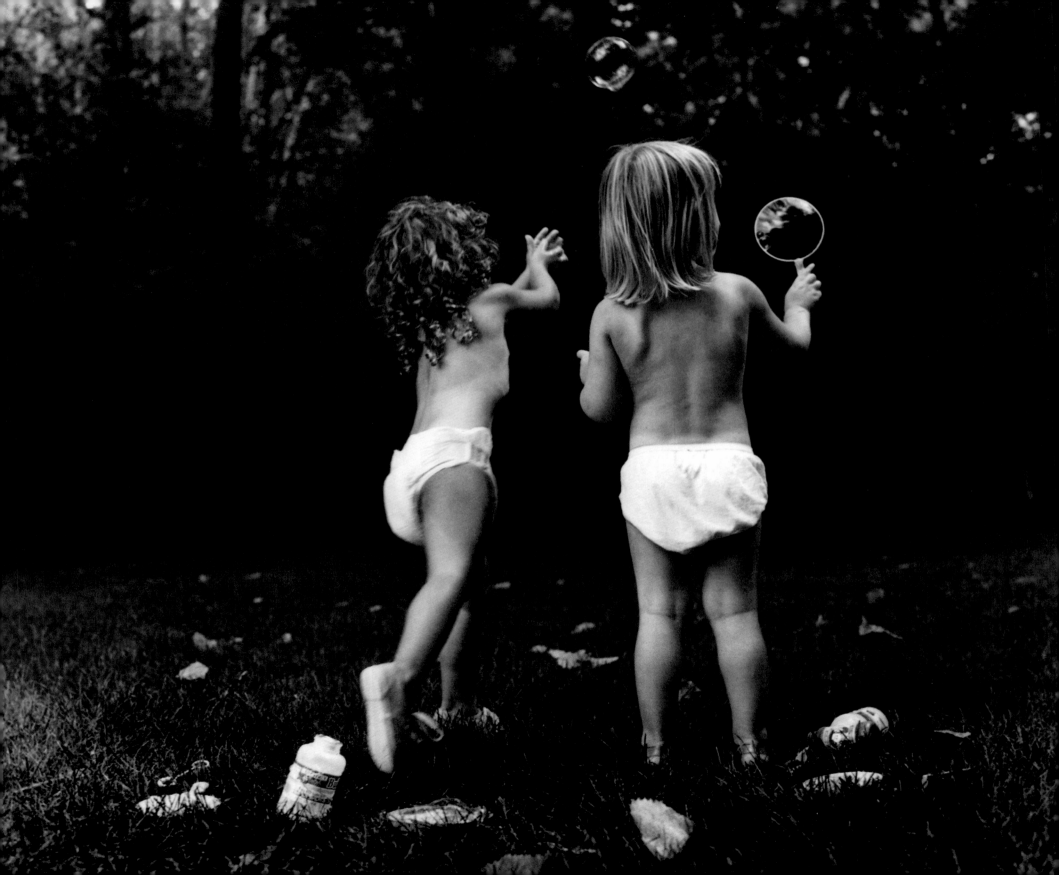

lauren eiden *and* gabrielle ilana levine

Gabrielle Levine was an orphan in Russia, living in a small town not far from Moscow. Lauren Eiden was born into a child-centered universe. They met on Gabrielle's first day in her adoptive home, outside Chicago. They are now best friends.

Maybe they were drawn to each other because their parents were friends. Maybe Lauren was so outgoing and spirited that Gabrielle couldn't help but follow her lead. Asked why, they offer only a shrug and say, "Because I like her" and "We have fun."

One night, they found themselves at an adult dinner party, searching for something fun to do.

Their mothers were pleased—not only that their daughters were together, but that they were so absorbed in each other.

They toasted to the simple delight of their daughters as first friends. By dessert, when they still hadn't heard a noise, they knew something was going on.

Up the stairs they went, to Lauren's room, where they thought they'd find the girls playing house or dress-up. Instead they found Gabrielle and Lauren naked in the bathroom, sliding back and forth on the wet tile floor, having emptied the toilet and transformed the room into a skating rink.

In the world of toddlers, friendships are fugitive things. One minute their world is a perfect bubble of happiness. The next, one child sees the other wearing that Cinderella dress she suddenly, desperately must have, and tragedy ensues.

But when toddlers are happy, they'll run toward each other as if they haven't talked in days, hugging and bouncing, knowing that together, they're safe enough to bare all.

rebecca guberman
and # jennifer jako

before they met, Rebecca Guberman and Jennifer Jako were both certain they were fated to be alone. They had boyfriends who loved them. They had beloved friends. But there would never be anyone who could really understand, who could say, "Yes, I know what you're feeling," and mean it.

They were young then, and beautiful—Rebecca was seventeen, and Jennifer, whom everyone calls Jako, eighteen. Both had thought little of what it might mean to die. But both had learned they had the virus that causes AIDS. Then, coincidentally, they moved to Portland, Oregon, and enrolled in the same art school.

Now, four years later, they've experienced, with great pride, the airing of their MTV documentary about young adults living with HIV, called, *True Life: It Could Be You*. The film was awarded the 1999 Ribbon of Hope Award from the Academy of Television Arts and Sciences.

Still, they can't quite believe they found each other.

"I mean, what are the odds?" Rebecca asks. "I just have to shake my head."

Friends and filmmakers Jennifer Jako (left) and Rebecca Guberman fooling around.

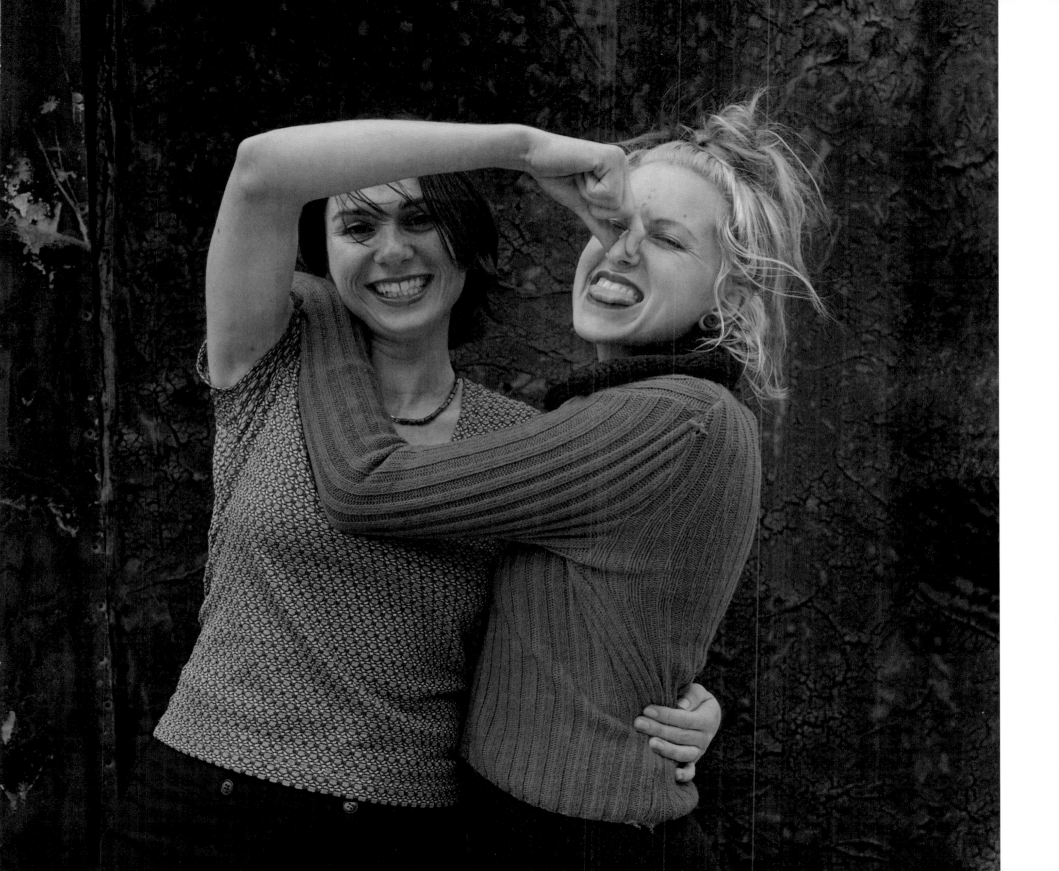

"It's amazing when you think about it," Jako agrees. "No matter how close we were to someone—how close I am to my boyfriend or other friends—they are not HIV-positive. There are things they're never going to understand. Intense things, small things—all of it."

"Like the pill swallowing," says Rebecca. "The therapy. Watching people you love, who have what you have, waste away and die."

"Or the whole baby thing," Jako adds. "We've talked about that a lot. It's become this huge loss. Or even just about how we're afraid to have sex, how we feel dirty. Who else is going to understand this?"

"Right," says Rebecca. "The only HIV-positive people I knew when I was diagnosed were gay guys. I'm sorry, but a thirty-year-old gay guy just doesn't know what I am going through."

Both women speak rapidly, which is much the way they live—trying to fit a lot into a little space. They are bonded through disease, as members of a club neither wanted to join.

"Before I met Jako, I was so isolated," Rebecca remembers. "I felt so different, as if everyone looked at me and said, 'Oh, that's the girl who has HIV.' When I met her, it was like suddenly having my eyes opened—this amazing feeling of empowerment."

At the time, Jako was timid, frightened by conflict, and by the anger inside her. Rebecca, much more confrontational, said just what she thought. But, she was also plagued by feelings of inadequacy and fear—bold and brave on the phone with Jako,

or while mentally planning a project, but in reality too frightened to pick up the phone and ask someone for money or help.

"When I met Jako, I was really afraid," she says. "I was so shy about expressing myself and my art."

But together, one helped the other. Rebecca found the courage to act on her creative impulses, and Jako learned that sometimes confrontation and hurt feelings are simply inevitable.

"It's almost as if we were meant to be sisters," Rebecca says. "We have similar thoughts, issues, aesthetic sensibilities, sensitivities. I look at Jako and it's almost like looking at myself, yet in a totally different way. Like we're two sides of the same coin."

"It's so strange," says Jako, "because people always confuse us—they call her Jako and me Rebecca."

"We even confuse us!" Rebecca marvels. "One day I called Jako and I'm like, 'Hi, this is Jako. I *mean* Rebecca!' At some point, I lost my identity. Even I thought I was her!"

from almost the moment they met, in a coffee shop in downtown Portland, they decided to make a film together. It was February 1995. Both had just won scholarships to a national AIDS conference. They met to discuss the issues they might present to a government panel at the conference, with the burning ambition to tell a story that might move others— particularly teenagers who think, as they themselves once

did, that mortality is not an inevitable by-product of life.

"We were talking about a collaboration as a way to express what we were going through," Jako says.

"Neither of us recalls saying something about a film," adds Rebecca. "It was as though it just happened."

They had no money, little film experience, and no idea how to find their subjects. All they knew was that they wanted to interview a variety of HIV-positive men and women who could tell their stories in a way that would demystify the disease, but also make it very personal.

For three years, they worked on *True Life: It Could Be You,* researching, traveling, raising funds, and putting together pieces of their vision. Through it all, their friendship became a test of their own commitments as well as a triumph of their faith in each other.

At times, they fought bitterly, falling back into their old habits: Jako backing away from confrontation, Rebecca trying to instigate it. They sat down with a mutual friend skilled at mediation.

"I was always avoiding conflict. I wanted to just let it go," says Jako. "That didn't work for Rebecca. She would just fume, and I'd be like, 'I don't want to talk about it.'"

"It would infuriate me!" remembers Rebecca. "The more silent she was, the more aggressive I would get."

Now, they laugh just thinking about how much like an old married couple they must have sounded.

But from the very beginning, they found ways to let go of all the seriousness that was between them.

One day, while on a trip for their film, they were practicing their camera skills in a hotel room. They ended up studying each other in the bathroom mirror.

"You have to understand—and I don't want people to get the wrong idea from this—but both Rebecca and I are kind of nudies," says Jako. "We don't care if we're walking around with clothes on or not. So we were in the bathroom with towels wrapped around our heads and I don't know how it started, but we started comparing our boobs, like, 'Look, yours are bigger than mine.' We were like little girls who were finding out about their own bodies by looking at their friends, it was just very innocent."

"And then for some reason . . ." Rebecca pushes her on.

"For some reason we started jumping up and down, and we decided to film our boobs because they look so funny on film and . . ."

"It was hilarious!" They're both hysterical now, at the memory of how they watched that piece of film over and over, laughing uproariously. But even as they tell it, they know no one else—not boyfriends, nor loving friends—can truly appreciate it without seeing their world, for that moment, through their eyes.

So they move on.

"It's hard to explain," Rebecca concludes. "I've never had a friend like Jako. It's as if our friendship passed over some barrier where she's like family, but she's not family. Even when I'm not with her, she exists inside me in some way."

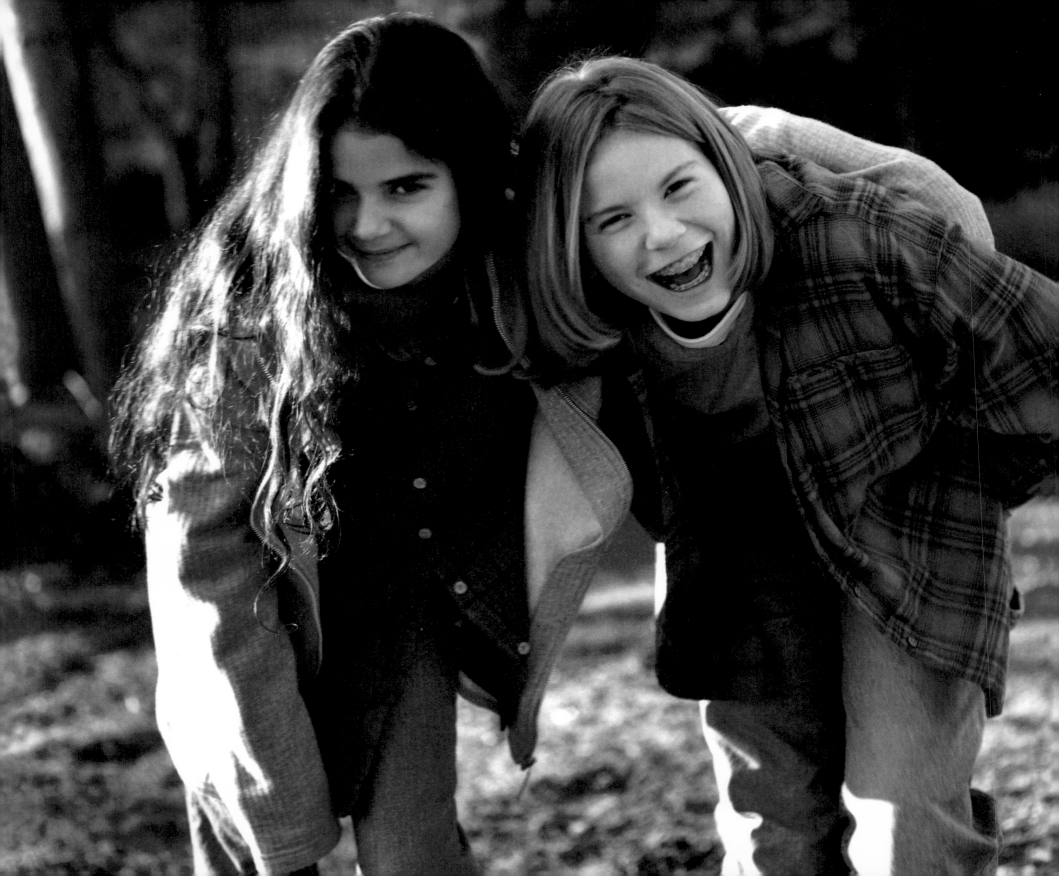

sammerah qawasmy
and kate fluehr trainor

Sammerah Qawasmy and Kate Fluehr Trainor knew what it meant to be an outsider. Both understood the pain and humiliation of being teased—Sammerah because she was small and neither white nor black; Kate because she was adopted.

Then in fourth grade, Sammerah moved to Kate's school. They became friends, and their lives seemed suddenly changed.

"Before, I'd be walking to school, saying like, 'Please don't let them tease me,'" remembers Kate. But with Sammerah at her side, "I felt much safer . . . like someone was watching over me."

Where other girls their age dress the same, or try to look alike, Sammerah and Kate celebrate their physical differences. They feel like they have something the same inside them.

"She always knows just how I feel," Sammerah says. "If I didn't have her, I don't know what I'd do."

"I would have nobody," Kate responds firmly.

This is not entirely true. She has her mother, whom she talks to easily, and often. And an older brother, and a little sister who sometimes drives her crazy. But a friend is different—especially one who stands up for you when someone else puts you down.

"She's like a sister, but better," Kate explains. "She knows what you're going through because she's been through the same thing."

For Sammerah's last birthday, Kate made her a picture frame of popsicle sticks that holds an image of the two of them. It's trimmed in gold glitter, with "Best Friend" across the top and "To Sammerah" "From Kate" along the sides. On the back, it reads, "Thank you for being my friend. Thank you for standing by me. I'll always be there for you."

Sammerah Qawasmy (left)
and Kate Fluehr Trainor palling around.

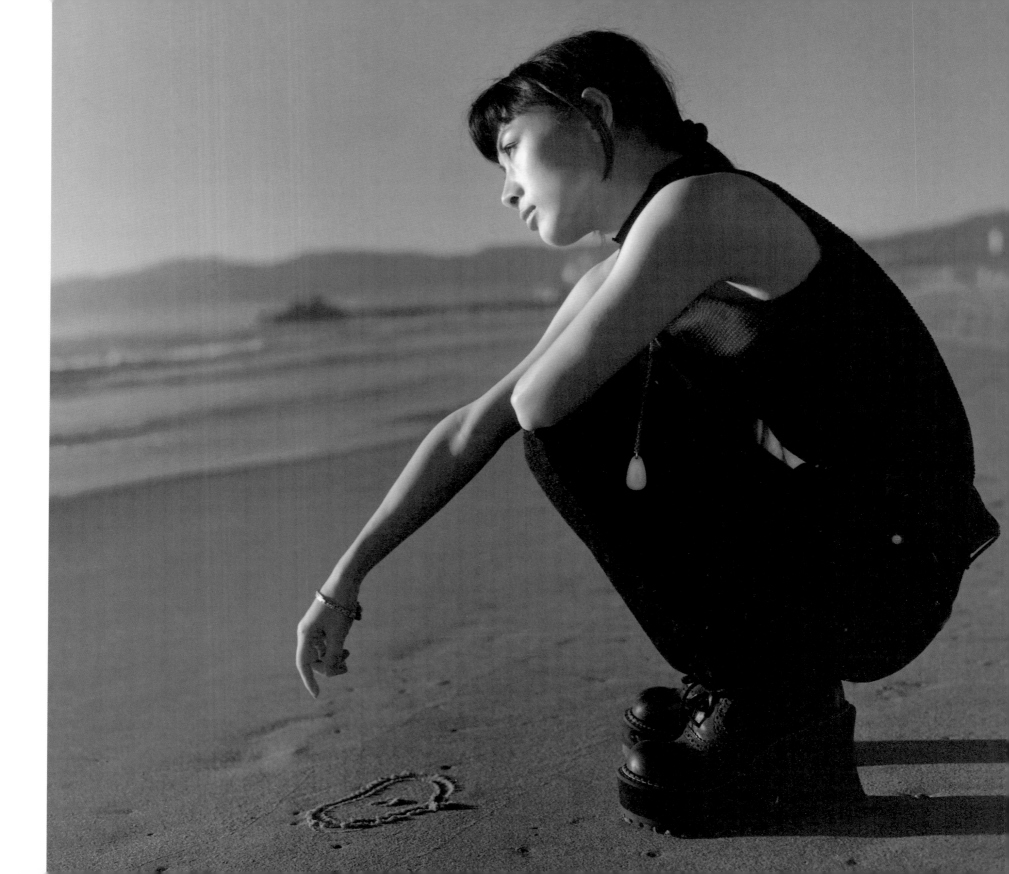

bai ling
and mao tian yuan

in her mind, Bai Ling can picture the last time she saw her beloved friend, Mao Tian Yuan. Bai had returned to her hometown in mainland China, having just been cast in the film *Red Corner*. The film was a turning point in her career. However, its release would so anger Chinese officials that Bai would realize she could not return home.

But on the day she saw her friend, she didn't know that. She was walking through the university streets she knows by heart, and she remembers feeling feverish, perhaps because she was sick or because her heart was pounding so fast now that her feet were on the landscape where she was born.

Then suddenly, she heard someone calling her name. She turned to see Mao, though for an instant she did not recognize her. *Mao, look at Mao! Orange coat, red scarf, bright red lipstick. And a child—a little girl,* Bai realized with astonishment. *Mao has a daughter!*

Mao was screaming with delight: "Bai Ling! Bai Ling!" Hugging her with tears in her eyes, just as she did when they were fourteen and Bai was leaving home to join the People's Army.

They had not seen each other in years. And for a moment, Bai felt as though everything had stopped, as though she was no longer drifting.

115

"I'm sure even as I am talking of her now, she can feel it," Bai Ling says, recalling their reunion. She is in her apartment in Marina del Rey, California, watching a butterfly outside her window. "I look at her and see her laughing—she was laughing all the time. She says, 'Come to my house, come home with me.' I talk with her about our friendship. I think, 'She always wanted to be a dancer, to perform, to do what I am doing.' But she says, 'Bai Ling, I found my dream. I live my dream through you.'"

When Bai Ling talks of friendship, she talks of freedom. All during her childhood, she found one by exploring the other. But in choosing freedom, she knows there's a good chance she won't see her friend again.

She grew up in the Szechwan province, in Chengdu. As a young girl, shy and quiet, she was taken from her parents, who were professors, and raised by her grandmother, whom she adored. Even then, she sensed the suffocation that comes with a life of rules and limits. But with Mao Tian, she was free to run after butterflies, get into mischief, and ride her bike with abandon.

As an adult, she chose to leave China and escape to the United States, just after the fateful student marches in Tiananmen Square. She left behind her beloved grandmother, and many good friends—those who had always known her, like Mao.

In this country, Bai Ling found much that she had been looking for—a successful career and a chance to see the world, as well as a forum in which to speak her mind. She won the role opposite Richard Gere in *Red Corner*, a not-so-subtle condemnation of the Chinese political system. She was a Chinese actress in a mainstream film opposite a white male star—and her performance opened a flood of opportunities. She also found herself stranded between two lands—drifting alone in the United States, but in real danger from the government in her homeland because of the viewpoint expressed in *Red Corner*.

When she ran into Mao back home before *Red Corner* was released, it struck Bai Ling that this precious friend had, when they were children, given her a great gift, allowing her to find the freedom she had so dearly needed.

"Of course, I didn't see it that way as a child," she explains. "Then, I only knew that I was with a girlfriend, and we were sharing secrets, doing mischievous things."

With Mao, even small outings became great adventures. Bai remembers them giggling as they spent precious pocket money on exactly what they had been told not to buy—sweet dumplings. She remembers them huddling in a restaurant, mixing table sauces together with a chopstick and marveling at the messy results, the way American kids might loosen the top of a salt shaker and wait for an unsuspecting person to use it.

"They were simple things that as a child are like magic, that free your spirit," she says. "They are things society tells you not to do."

Bai was thrilled when, at fourteen, she was recruited into the

People's Liberation Army. She longed for adventure, and was drawn to the mysterious culture of Tibet, where she would train. She adored the army's fine red uniforms, and saw a costume that might transform her.

In her mind, she can still hear Mao crying, the day she heard her friend was leaving. "When I got the news, she rode over on her bicycle. She was yelling at me from downstairs—I lived on the third floor. She tossed her bicycle, ran to me, and hugged me very hard. She was crying very, very loud. I felt like she was crying for me."

Through some quirk of fate, the army assigned Bai Ling to be a performer, and she began to study acting and dancing. Soon, she was appearing around the Chinese countryside with the troupe and came to the attention of local playwrights. By the time the government cracked down in Tiananmen Square, she was eighteen and had performed in a host of films and theatrical pieces. She had seen the Square the day before the crackdown and knew of friends who were there.

Then she got the chance to study at New York University's film school as a visiting scholar. Though her ambition drove her, it was the events in Tiananmen that distilled the choice, which until then, she says, had just swirled in her subconscious. Suddenly, she felt the need to leave, as acutely as someone who is choking needs air.

"Much of me did not want to leave China," she says. "I knew I wanted to achieve more, to explore the world.

But after Tiananmen, there was much in me that was sad."

Since coming to the United States, Bai has received many film offers. She has appeared in *The Crow*, *Nixon*, and most recently *The Wild, Wild West* with Will Smith and Kevin Kline. At the time of the interview, she was shooting a leading role opposite Jodie Foster in a dramatic retelling of *The King and I*.

Bai says she has become more Americanized, though the day she became a naturalized citizen was tinged with sadness. Still, she says, she feels as if she is drifting, rootless. She absorbs lessons from her new life, but feels grounded by memories of home. Recalling times like those she last spent with Mao, she has a feeling of connectedness, of being drawn, if only for a moment, back to Earth.

"Sometimes I feel like I'm alone, that my soul, my spirit are like air," she explains. "When we part from friends, it is very, very sad to say good-bye. But even now, I am standing here remembering. I see her laughing. Maybe I do not remember exactly what she said. But I feel her, like she is inside me.

"I realize now that I have always been fighting against some rule—especially in China," she continues. "There I am fighting a system, a government, parents, the rules of family, the rules of society.

"What I am looking for, all my life, is that feeling we have when we are children—when we are with a friend, and our spirit is free."

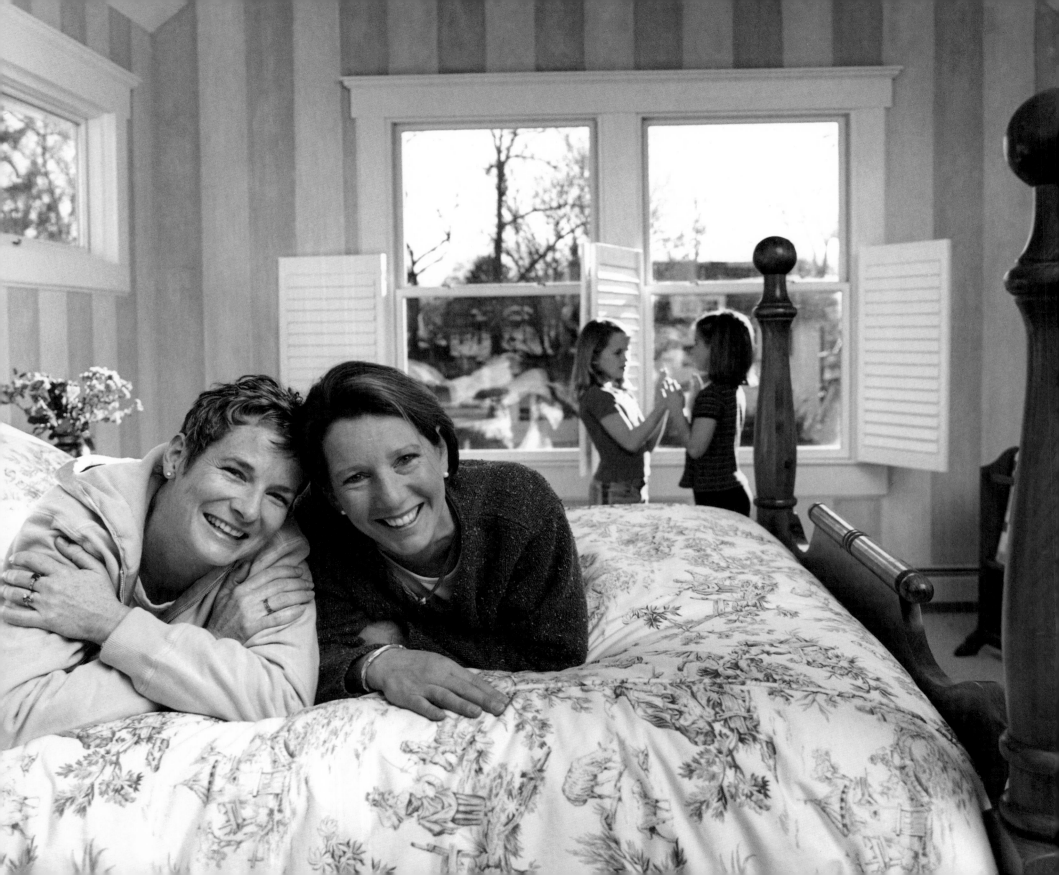

ellen allen _and_
karen neal-mustard
nicole allen _and_
haley mustard

They were both from Canada, living in Brooklyn Heights, and working in Manhattan—which isn't that far from Toronto, but seemed a million miles away.

So when they met, Karen Neal-Mustard and Ellen Allen figured that if they ran out of things to talk about, at least they'd have Canada.

As it turned out, they would have enough to fill several lives. They were pregnant at the same time, and their respective daughters, Haley and Nicole, were born three months apart. Then they had a second and third child, born near enough to one another that Karen feels compelled to say, in mock defense, "It's not like we took our calendars . . ."

Five years after they met, she and Ellen moved to different cities with their families, bound to each other as friends who have seen their lives change in the same way at the same time.

"We were both coming from our work lives, making the transition to motherhood," says Ellen. "And there was no pretension, no baggage."

"Our husbands connect, our children connect—it's just this very easy thing," says Karen.

Often their families vacation together, and, as they did on a recent rafting trip, the mothers will sneak off for their own private adventure.

"There we are," recalls Ellen, "we've got our old running shoes on, and these flimsy air mattresses, and we just get on our cheap rafts and go down the river, laughing.

"When you're with your kids all the time, you're constantly having to attend to the details. When I'm with Karen, we have simple fun, like kids."

As for their daughters, Karen notes, "They're each other's first friends."

Girlfriends Karen Neal-Mustard and Ellen Allen, and their daughters, Haley Mustard and Nicole Allen (left to right), in Karen's bedroom.

SCENE ONE

Two college students inside a dilapidated room that used to be part of a whorehouse and is now serving as a New York City dorm. Plaster falls from the ceiling. Beds are thin and squeaky. Dim light comes only from a dirty window that looks out to an air shaft—though if you squint upward, you can see daylight. Students are would-be screenwriters. DEANN is girl-next-door blonde, hopelessly optimistic despite living in such a place. EILEEN, the first Jewish person DeAnn has ever known, is dark and ironic. She is not optimistic.

EILEEN

We're not living here!

DEANN

Oh, come on. It's not so bad. (A big chunk of plaster falls on her head.) Okay, it's pretty bad.

EILEEN (pacing)

Look around you. This is a hell hole!

eileen heisler *and* **deann** heline

So began the partnership that would become a match made in sitcom heaven. Eileen Heisler and DeAnn Heline are now a rare commodity, one of the few female comedy-writing teams in television. They have an exclusive development deal with NBC television. That means they spend their days in a nice office in Burbank, California, where their main obligation is to write funny scripts for television shows.

They've penned scripts for *Doogie Howser, M.D.*, *Roseanne*, where they were on staff, *Murphy Brown*, which they produced, and *Ellen*, where they were executive producers. At thirty-four, Eileen is pregnant with twins.

Writers Eileen Heisler (left) and DeAnn Heline— and their piles of comedy scripts— at DeAnn's home in California.

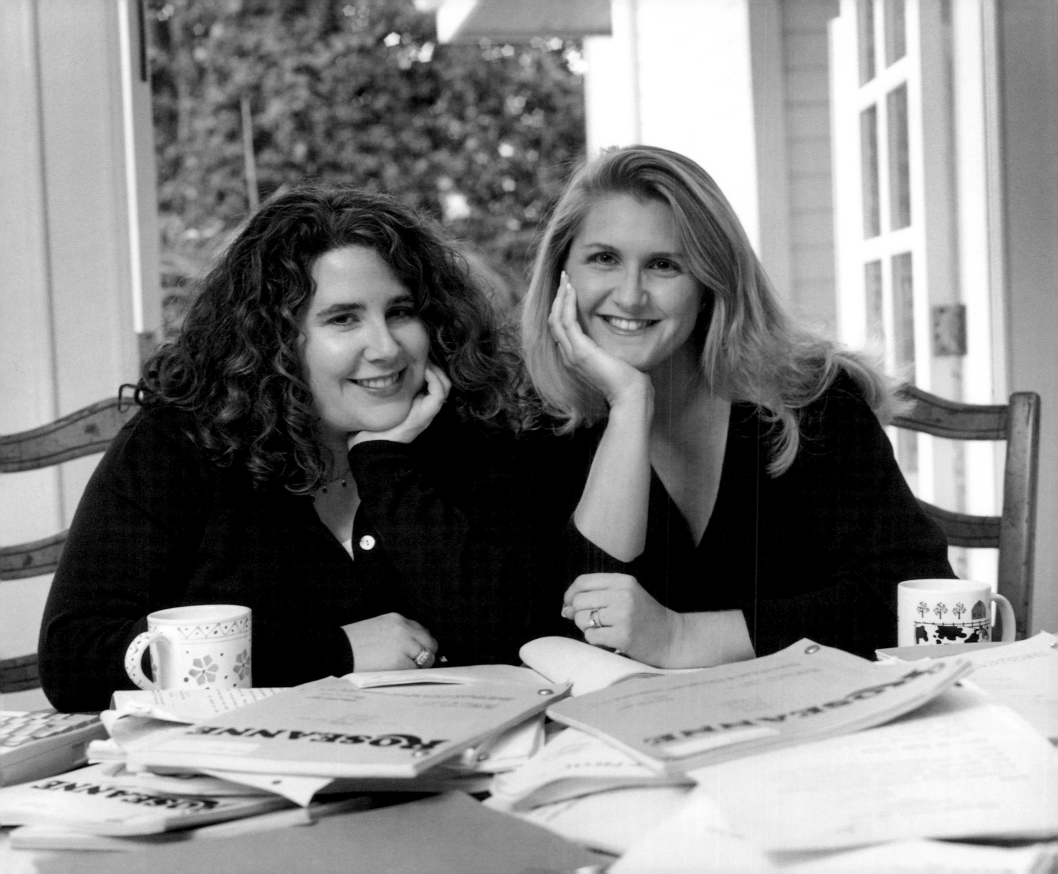

DeAnn has a child. Both have become expert at juggling what they regard as two marriages—one to their respective husbands, and one to each other, whom they see more often, they admit, than their spouses.

Back in 1985, at New York University, they began as collaborators at ground zero, writing scripts, performing in each other's films, and living in the famously unglamorous confines of the Seville Hotel, where the college maintained two floors of dormitories. DeAnn, ever hopeful, wrote in a journal once that she saw herself as an executive producer of a successful television show. Had she seen DeAnn's journal at the time, Eileen would have told her she was crazy.

SCENE TWO

On the set of *Doogie Howser, M.D.,* EILEEN is a low-level assistant, waiting for her first break. She and DEANN, who has a similar job, have recently moved to Los Angeles. At night, they write scripts together. One of their scripts was recently reviewed by *Doogie Howser* brass, who said they liked it but did nothing with it. Now EILEEN is face-to-face with someone who, she learns, has come to pitch stories to Steven Bochco, the executive producer and creator of the show.

EILEEN (eyeing guy who has come into offices on the set and asked her for a script):

Sure, yeah, here's the script. Where are you going with those?

GUY (acting like he's somebody)

I have an appointment to pitch scripts to Steven Bochco.

EILEEN (fishing for information)

Really? How did you get to do that?

GUY

Well, I sold Bochco a car. (Guy leaves.)

EILEEN (picks up the phone and calls DeAnn)

This is bullshit. We're answering phones while a guy who sold Bochco a car gets in to pitch. We've got to do something.

FADE OUT

EILEEN (dialing number, putting on professional voice):

This is Eileen Heisler, you know my partner and I have a lot of great ideas we'd like to pitch.

EILEEN (calling DeAnn again)

I did it. We're going in next week to pitch our great ideas.

DEANN (excited)

What ideas?!

For a week, they worked feverishly, pounding out story ideas. They began what became a ritual argument, each insisting the other begin the pitch. Eventually, they'd learn who was good at what. DeAnn hates the phone, hates socializing. Eileen is more vocal. "DeAnn's a cat, and I'm a dog," she explains. "DeAnn's like, 'If you want to talk to me, you'll have to come over here.' I'm in their face, panting: 'Like me, like me!'"

DeAnn can't even remember that first pitch meeting. She remembers what came before and after. She remembers being in the car, in Century City, unable to breathe and sick to her stomach, telling Eileen, "If they want to hear the pitch they're going to have to come to the car, because I'm not moving."

Eventually they made it out of the car and into the producer's office. An hour and a half later, they left with the sense that (a) they had been way overprepared, and (b) their idea for a *Doogie Howser* script was a hit.

A week later, the producer called them back. He'd pitched it to Bochco, who loved it. They were off and running.

That night, they had their first "Dom and Dom" party—a bottle of Dom Perignon and a Domino's pizza.

SCENE THREE
Inside Coffee Roaster's coffeehouse in Marina del Rey. Papers are spread on the table, with Eileen and DeAnn on either side.
EILEEN (reading a script)
This doesn't suck. You always do that—you work yourself up. It's really good.
DEANN
You think so? (relieved) Good.
EILEEN (watching DeAnn read)
You're not laughing.
DEANN
I laughed the first two times when you read it over the phone.
EILEEN
But what about that new part? That's funny, don't you think?
DEANN
Funny. Hmmm.
EILEEN
Okay. We'll rewrite it. But wait—this here (pointing to page). This should be a question mark.

DEANN (emphatically) You think so? I say a period.

The only thing they fight about—really—is punctuation. That, and the room temperature. Which is unusual, given that they've been writing together for nearly fifteen years.

In their development deal with NBC, as in all other collaborations, they split the seven-figure salary. They know they're at the point where great teams often break up to try launching solo, possibly more lucrative, careers.

But for DeAnn and Eileen, their friendship is not just a source of great strength, but also great material. They have had many proud moments—such as the day when they met with representatives from the sitcom *Wings* in the morning and *Roseanne* in the afternoon, and by evening had gotten both jobs. The year they spent writing for *Roseanne* was, they say, "the best of times and the worst of times"—creatively rewarding, but so demanding that they often worked until 3 A.M. It was also DeAnn's first year of marriage.

They are currently working up new ideas for NBC, talking to each other in code.

"It's not that we end each other's sentences," Eileen says, "it's that we never have to start them."

Meanwhile DeAnn remains the optimist, the one who makes telephone calls only when Eileen is ready to explode. In writing, however, they feel their relationship is fifty-fifty, and they have tremendous respect for each other's talents. Except when it comes to punctuation.

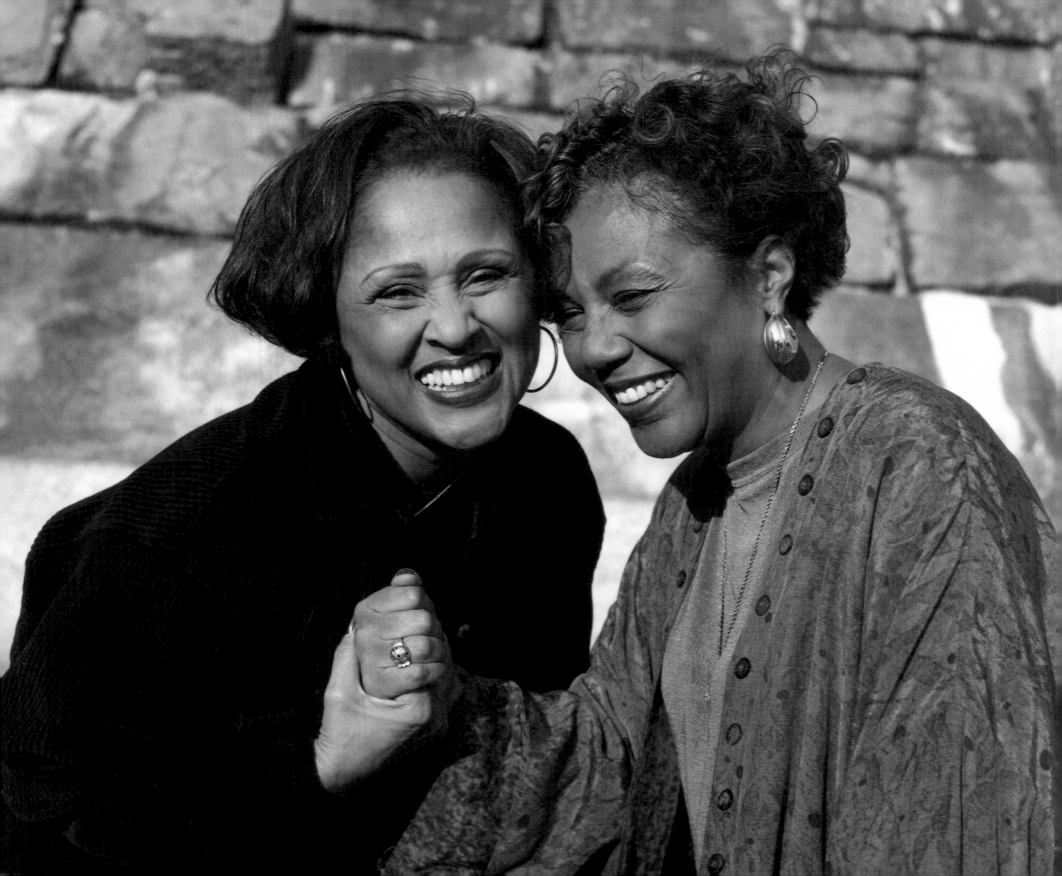

barbara johnson-armstrong
and darlene love

Should you happen to catch a performance by Darlene Love, you may notice a woman in the audience. If you don't see her, you will probably hear her.

She's the one in a back corner, whooping and hollering, waving like a maniac, stomping her feet, shouting to her best friend, "Yes, girl! You go!"

Darlene Love, whose voice was hailed by the *New York Times* for being "as embedded in the history of rock and roll as Eric Clapton's guitar and Bob Dylan's lyrics," was one of the epochal "girl group" vocalists of the 1960s, associated with producer Phil Spector's famous "Wall of Sound" recordings. She headlined the group called the Blossoms, toured with Bob B. Soxx & the Blue Jeans, and sang backup for everyone from Elvis Presley to Aretha Franklin. To fans of the *Lethal Weapon* films, she's the actress who plays Danny Glover's wife, and she now often sings in a cabaret setting. But to Barbara Johnson-Armstrong, who teaches special-needs kids in Irvington, New York, she's just her closest friend, "Doll."

Never mind that at this moment, Doll is on a Broadway stage and can't exactly stop mid-song to say, "Barbara, I see you there. I love you."

Instead, Darlene tries subtle hints. She winks at Barbara, and nods her

125

head as if to say, "Yes, honey. I hear you. Now hush!"

Barbara doesn't care if she's heard. She's been there for Darlene since before her career took off, when Darlene, the daughter of a prominent preacher, left her family home in Los Angeles (where Barbara also lived for a time with Darlene's family)—and struck out on her own, daring to sing that illicit new form of music known as rock and roll.

And when Darlene's fate later plummeted, and she was nearly out of money, Barbara was there, too.

Now when Darlene is on stage, as she was at the once famous Rainbow and Stars or promoting her new gospel CD, "Unconditional Love," or at a reading for her recent autobiography, *My Name Is Love,* Barbara is out there doing what she always does—shouting and dancing as though both their lives depended on it.

And Darlene knows she can't stop her. "What can you do?" she deadpans one day in Barbara's kitchen. She's opening and closing cabinets she knows as well as her own, while Barbara sits astride a bar stool, laughing so hard she's crying.

"I can't wave!" Darlene continues. "I'm trying to be subtle, you know? I'm trying to give her a sign. She's up there waving like this. 'Do you see me? Do you see me?' I'm like, darling, how could I *not* see you!"

The fact is, Darlene and Barbara don't need to see each other to know the other's there. They have a way of knowing that is so keen, so finely attuned, that they can be thousands of miles apart and Barbara will sense, suddenly, that Darlene needs to talk to her. Then, sure enough, the phone will ring.

"You just get a feeling," explains Barbara. "You hear whispers. You're thinking about somebody, but it's far back in your mind. You're not even aware you're thinking of them. And then they call and you say, 'Oh my God, I've been thinking about you for three days!'"

"There are things I would do for Barbara that I wouldn't do for anybody else," says Darlene. "I would lay down my life for Barbara, like I would for my kids or my mother. Now these other friends, I may love them, but I ain't gonna lay down my life for them, you know what I'm saying?"

They met when both were teenagers. Barbara, attending college in California, met Darlene's sister and moved in with Darlene's family.

"Darlene's father was a bishop so it was a big number that Darlene sang rock and roll," notes Barbara. "I mean to some people in the church, it was not to be mentioned. But it's like everything else. When you love somebody, what does it matter?"

Barbara wanted to hear everything about Darlene's adventures, and to let her know she was with her in spirit even if she couldn't actually be there with her, in Los Angeles. After Barbara moved to New York, married, and began teaching special-needs children, she'd keep up through Darlene's family, or by reading about her friend in the newspaper. Eventually, as the sound of the sixties gave way to the psychedelic seventies, Darlene and her kind of music mattered less and less.

Neither Darlene's family nor Barbara knew that by 1982, Darlene had lost nearly all she owned and had taken a job cleaning houses to make ends meet.

When they did talk, Darlene was not one to complain. Sometimes, recalls Barbara, she'd just get a feeling that Darlene needed something. "Out of the clear blue," she says.

Then Darlene would find an envelope with money in her mailbox. No explanation needed.

Finally, when Darlene's father died, she packed up and moved back east, to New York City where Barbara lived, to start over. It was as if she were moving to a second family, which is what Barbara and her family had become.

In her most difficult moment, she became involved in a long and highly publicized court battle with her former producer, Phil Spector, who had a powerful defense team. Darlene sued him, seeking compensation for the royalties she claimed she was owed. One day, in the courtroom, she felt something behind her, like a rush of strength to her shoulders. Darlene turned around and there was Barbara, looking daggers at Spector's attorneys.

"It's so hard to see someone you love go through humiliation," Barbara says, anger still in her voice. "They must have spent months strategizing on how to make Darlene feel like nothing. I was sitting in back of them, you see. And I'm just sending all of my energy to Darlene. I swear, I'm staring at them so hard it felt like I was boring a hole through them."

"Here they were calling me a liar," Darlene explains, "And when I turn around and see Barbara's face, it's like, 'Yes. She has my back.' That fact made all the difference in the world. I felt

like saying [to Spector's people], 'You think you got power? Well, I got the power of God—and Barbara—on my side!' "

Hearing this, Barbara sits quietly for a moment, tears welling in her eyes. "I always think of our relationship as a special part of my life," she says finally with a sigh. "It's like if you could wish one thing for the universe, I would wish for a relationship like this.

"No matter where we are, or how long it's been since we last talked, we don't have to go through the preliminaries," Barbara notes. "We just jump in and know that this friend will stop and listen and weigh in, and tell you the truth. That is one of the loveliest parts of our relationship. We can talk about everything."

Once, when she was a young teacher living in New York, Barbara saw an ad for the Blossoms, performing nearby that very night. It didn't matter that Doll, who still lived in Los Angeles at the time, was in town and hadn't called. Barbara would just go out and find her again. She called the theater.

"Is this the Blossoms with Darlene Love?" she asked the box-office clerk.

"The very same," he said.

"Could you please put her on the phone?"

"Who should I say is calling?"

Barbara thought for a moment. "Just tell her it's her sister," she said.

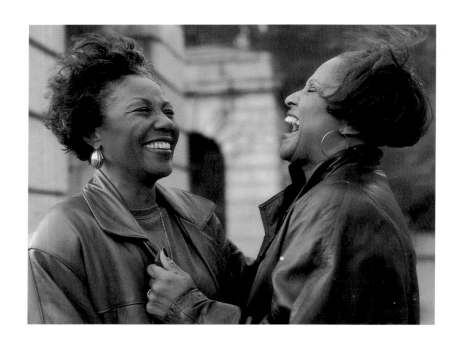